AMERICAN BEAUTIES

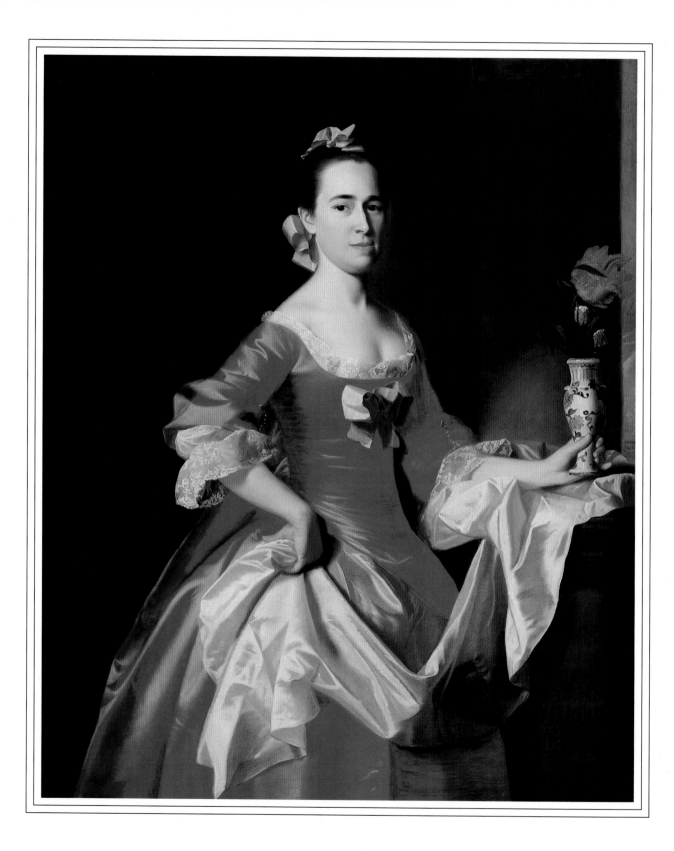

AMERICAN BEAUTIES

Women in Art and Literature

Paintings, Sculptures, Drawings,
Photographs, and Other Works of Art
from the
National Museum of American Art,
Smithsonian Institution

Edited by Charles Sullivan

Harry N. Abrams, Inc., Publishers
in association with the
National Museum of American Art,
Smithsonian Institution

Editor: Margaret Rennolds Chace

Designer: Carol Ann Robson

Rights and Permissions: Neil Ryder Hoos

Library of Congress Cataloging-in-Publication Data

American beauties: women in art and literature/edited by Charles
 Sullivan.
 p. cm.
 "In association with National Museum of American Art."
 Includes index.
 ISBN 0–8109–1927–3
 1. Women in art. 2. Arts, American. I. Sullivan, Charles, 1933–
NX652.W6A48 1993
700—dc20 92–25894
 ISBN 0–937311–05–7 (Mus. pbk.) CIP

Published in 1993 by Harry N. Abrams, Incorporated, New York
A Times Mirror Company

The National Museum of American Art, Smithsonian Institution is dedicated to the preservation, exhibition,
and study of the visual arts in America. The museum, whose publications program also includes the scholarly
journal *American Art*, has extensive research resources: the databases of the Inventories of American Painting and
Sculpture, several image archives, and a variety of scholarly fellowships. For more information or a catalog of
publications, write: Office of Publications, National Museum of American Art, Washington, D.C. 20560.

Printed and bound in Japan

Frontispiece: John Singleton Copley. *Mrs. George Watson.* 1765. Oil on canvas, 50×40". Partial gift of Henderson
Inches, Jr. in honor of his parents, Mr. and Mrs. Henderson Inches, and museum purchase made possible in
part by Mr. and Mrs. R. Crosby Kemper, through the Crosby Kemper Foundations; the American Art Forum;
and the Luisita L. and Franz H. Denghausen Endowment

During the past five years I have edited several books in which works of art are matched with literary selections to produce interesting, sometimes striking combinations. *America in Poetry* (1988), the first of those books, was followed by *Imaginary Gardens* (1989), a collection of American poetry and art for young people, and later *Children of Promise* (1991), which focuses on African-American literature and art. For each of them, I brought together a wide variety of material from diverse sources, including museums, art galleries, public libraries, archives, and private collections of one kind or another, all over the United States.

American Beauties is different from those earlier books in the sense that all of its visual contents are taken from the holdings of a single museum, and they illustrate only one subject: the beauty—broadly defined—of American women. When I began working on this project, in 1991, I was a little uncomfortable with the limitations of source and subject—but not for long. I soon found that the Smithsonian's National Museum of American Art has collections much larger than it can display at one time (35,000 paintings, drawings, sculptures, photographs, etc.), and I discovered that within these collections, the variety of visual images is enormous. With the help of the Museum's professional staff, I located countless images of American women of every shape and size, status and setting, age and vintage, in virtually every artistic medium. As it turned out, my most difficult task was to select no more than a hundred "American beauties" from thousands of colorful possibilities.

The selection of visual images for this book is entirely my own. I decided to include as many different artists as I could (although the Museum has very large holdings of some), in as many different media as possible, and have arranged their work in roughly chronological order, from 1776 (which I consider the first year of "America" as such) to the present. The result is a panorama of American women, covering two centuries, but it is not an intentional panorama (the Museum has not acquired its holdings with any particular concept of "women" in mind), nor does it make a political "statement" in the modern sense, although some changes in the status of women can be followed historically. To accompany these diverse images of women, I selected poems and other literary material by many different American writers, male and female, from approximately the same periods as the artists. Roses appear in some of the literary selections, as they do in some of the art, reflecting the "American beauties" theme.

Dr. Elizabeth Broun, Director of the Museum, was a great source of inspiration and support for this project. I would also like to thank Steve Dietz, Chief of Publications, and Kimberly Cody and Renata Kobetts of the Registrar's Office for their assistance. As the book goes to press, I am proud to add that I have just become a Charter Member of the National Museum of American Art.

CHARLES SULLIVAN
WASHINGTON, D.C.

TO HELEN

Edgar Allan Poe

Helen, thy beauty is to me
 Like those Nicaean barks of yore,
That gently, o'er a perfumed sea,
 The weary, wayworn wanderer bore
 To his own native shore.

On desperate seas long wont to roam,
 Thy hyacinth hair, thy classic face,
Thy Naiad airs, have brought me home
 To the glory that was Greece
 And the grandeur that was Rome.

Lo! in yon brilliant window-niche
· How statue-like I see thee stand,
The agate lamp within thy hand!
 Ah, Psyche, from the regions which
 Are Holy Land!

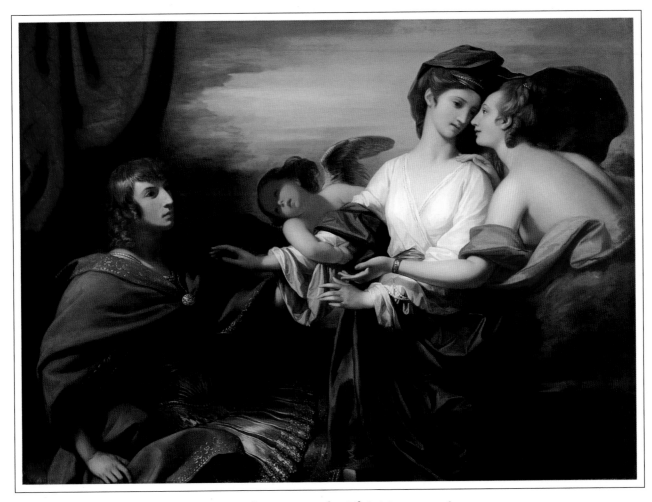

Benjamin West. *Helen Brought to Paris.* 1776. Oil on canvas, 56½ x 75⅜". Museum purchase

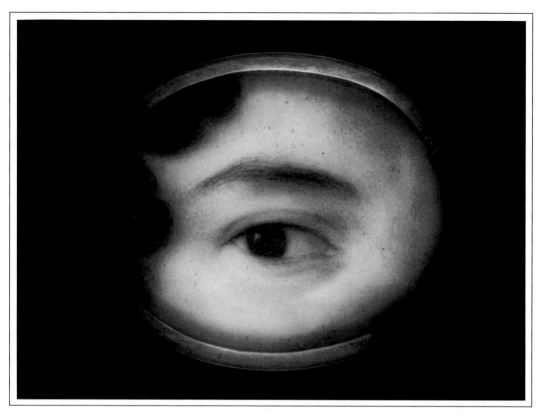

Unidentified artist. *Eye of a Lady.* c. 1800. Watercolor on ivory, $^{13}/_{16}$ x $^{15}/_{16}$" oval. Gift of John Gellatly

BEAUTY IS ITS OWN EXCUSE FOR BEING
From "On Being Asked, Whence Is the Flower?"
Ralph Waldo Emerson

Rhodora! if the sages ask thee why
This charm is wasted on the earth and sky,
Tell them, dear, that if eyes were made for seeing,
Then Beauty is its own excuse for being:
Why thou wert there, O rival of the rose!
I never thought to ask, I never knew:
But, in my simple ignorance, suppose
The self-same Power that brought me there brought you.

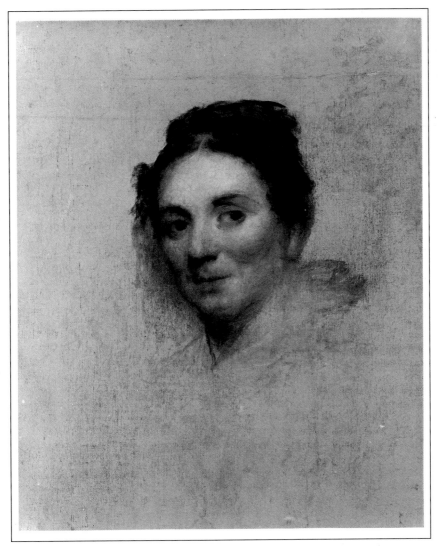

ART'S PERFECT FORMS

From "Songs of Labor"
John Greenleaf Whittier

Gilbert Stuart. Portrait of a Lady.
c. 1820–25. Oil on canvas,
22⅜ × 18⅜". Bequest of George
W. Story

Art's perfect forms no moral need,
 And beauty is its own excuse;
 But for the dull and flowerless weed
 Some healing virtue still must plead,
And the rough ore must find its honors in its use.

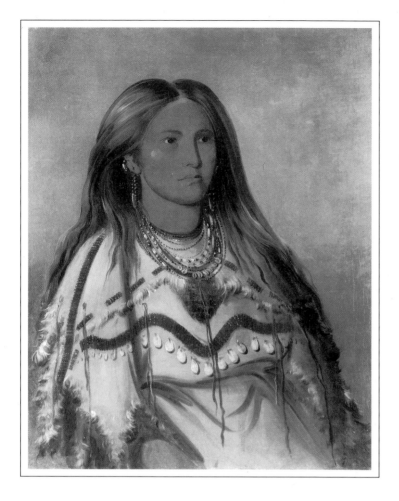

George Catlin. *Mint, a Pretty Girl.* 1832. Oil on canvas, 29 x 24". Gift of Mrs. Joseph Harrison, Jr.

INDIAN WOMEN TILL THE GROUND
From "Remarks on the Politeness of the Savages of North America"
Benjamin Franklin

The Indian Men, when young, are Hunters and Warriors; when old, Counsellors; for all their Government is by the Counsel or Advice of the Sages; there is no Force, there are no Prisons, no Officers to compel Obedience, or inflict Punishment. Hence they generally study Oratory; the best Speaker having the most Influence. The Indian Women till the Ground, dress the Food, nurse and bring up the Children, and preserve and hand down to Posterity the Memory of Public Transactions. These Employments of Men and Women are accounted natural and honorable. Having few Artificial Wants, they have abundance of Leisure for Improvement by Conversation. Our laborious manner of Life compared with theirs, they esteem slavish and base; and the Learning on which we value ourselves; they regard as frivolous and useless.

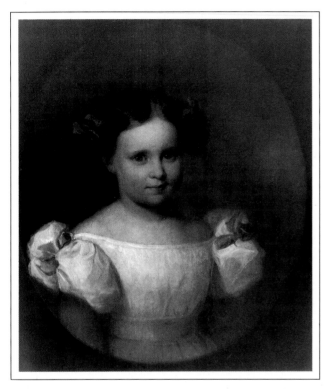

Asher Brown Durand. *Georgianna Frances Adams.*
1835. Oil on canvas, 24 x 20". Adams-Clement
Collection, gift of Mary Louisa Adams Clem-
ent in memory of her mother, Louisa Catherine
Adams Clement

OH FAIREST OF THE RURAL MAIDS
William Cullen Bryant

Oh fairest of the rural maids!
Thy birth was in the forest shades;
Green boughs, and glimpses of the sky,
Were all that met thine infant eye.

Thy sports, thy wanderings, when a child,
Were ever in the sylvan wild;
And all the beauty of the place
Is in thy heart and on thy face.

The twilight of the trees and rocks
Is in the light shade of thy locks;
Thy step is as the wind, that weaves
Its playful way among the leaves.

Thine eyes are springs, in whose serene
And silent waters heaven is seen;
Their lashes are the herbs that look
On their young figures in the brook.

The forest depths, by foot unpressed,
Are not more sinless than thy breast;
The holy peace, that fills the air
Of those calm solitudes, is there.

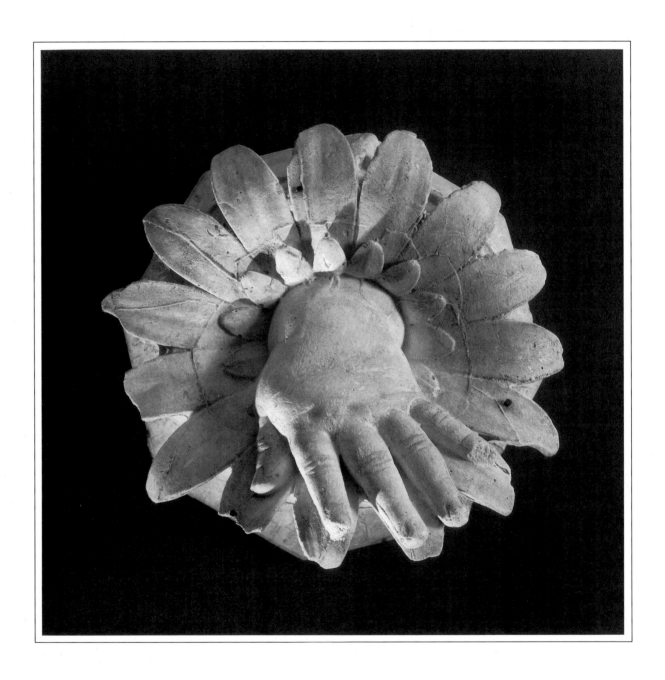

Hiram Powers. *Loulie's Hand.* 1839. Plaster, 5½ x 5½ x 2¾".
Museum purchase in memory of Ralph Cross Johnson

TO THE FRINGED GENTIAN
William Cullen Bryant

Thou blossom bright with autumn dew
And colored with the heaven's own blue,
That openest when the quiet light
Succeeds the keen and frosty night—

Thou comest not when violets lean
O'er wandering brooks and springs unseen,
Or columbines, in purple dressed,
Nod o'er the ground-bird's hidden nest.

Thou waitest late and com'st alone,
When woods are bare and birds are flown,
And frosts and shortening days portend
The aged year is near his end.

Then doth thy sweet and quiet eye
Look through its fringes to the sky,
Blue—blue—as if that sky let fall
A flower from its cerulean wall.

I would that thus, when I shall see
The hour of death draw near to me,
Hope, blossoming within my heart,
My look to heaven as I depart.

I DIED FOR BEAUTY
Emily Dickinson

I died for beauty, but was scarce
Adjusted in the tomb,
When one who died for truth was lain
In an adjoining room.

He questioned softly why I failed?
"For beauty," I replied.
"And I for truth—the two are one;
We brethren are," he said.

And so, as kinsmen met a-night,
We talked between the rooms,
Until the moss had reached our lips,
And covered up our names.

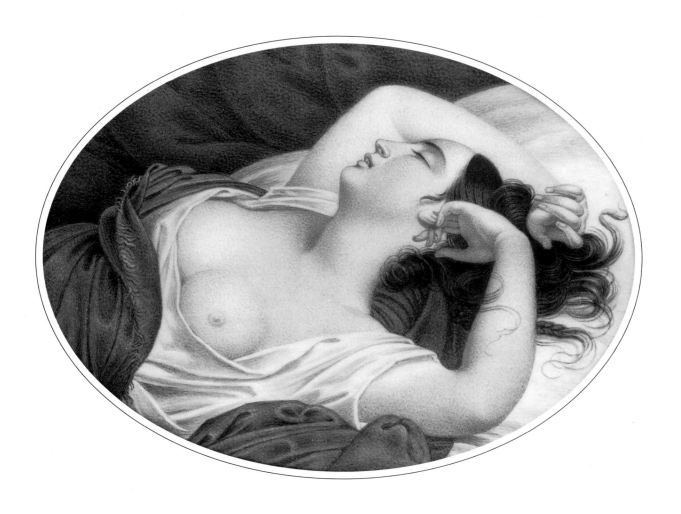

Henry Breintell Bounetheau. *Sleeping Beauty.*
c. 1850. Watercolor on ivory, 4¾ x 6⅝″ oval.
Gift of Mrs. Henry Du Pre Bounetheau

MAN AND WOMAN

From "Woman in the Nineteenth Century"
Sarah Margaret Fuller

The growth of Man is two-fold, masculine and feminine.

So far as these two methods can be distinguished, they are so as

> Energy and Harmony;
> Power and Beauty;
> Intellect and Love;

or by some such rude classification; for we have not language primitive and pure enough to express such ideas with precision.

These two sides are supposed to be expressed in Man and Woman, that is, as the more and the less, for the faculties have not been given pure to either, but only in preponderance. There are also exceptions in great number, such as men of far more beauty than power, and the reverse. But as a general rule, it seems to have been the intention to have a preponderance on the one side that is called masculine, and on the other one that is called feminine.

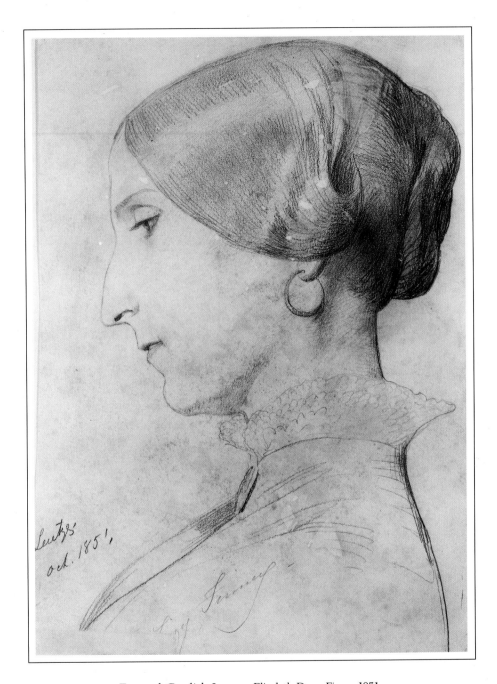

Emanuel Gottlieb Leutze. *Elizabeth Dunn Finney.* 1851.
Pencil on paper, 12³⁄₁₆ x 8½″. Gift of Mrs. Harry N.
Burgess

FOR A DEAD LADY
Edwin Arlington Robinson

No more with overflowing light
Shall fill the eyes that now are faded,
Nor shall another's fringe with night
Their woman-hidden world as they did.
No more shall quiver down the days
The flowing wonder of her ways,
Whereof no language may requite
The shifting and the many-shaded.

The grace, divine, definitive,
Clings only as a faint forestalling;
The laugh that love could not forgive
Is hushed, and answers to no calling;
The forehead and the little ears
Have gone where Saturn keeps the years;
The breast where roses could not live
Has done with rising and with falling.

The beauty, shattered by the laws
That have creation in their keeping,
No longer trembles at applause,
Or over children that are sleeping;
And we who delve in beauty's lore
Know all that we have known before
Of what inexorable cause
Makes Time so vicious in his reaping.

Lilly Martin Spencer. *We Both Must Fade (Mrs. Fithian).*
1869. Oil on canvas, 71⅝ x 53¾". Museum purchase

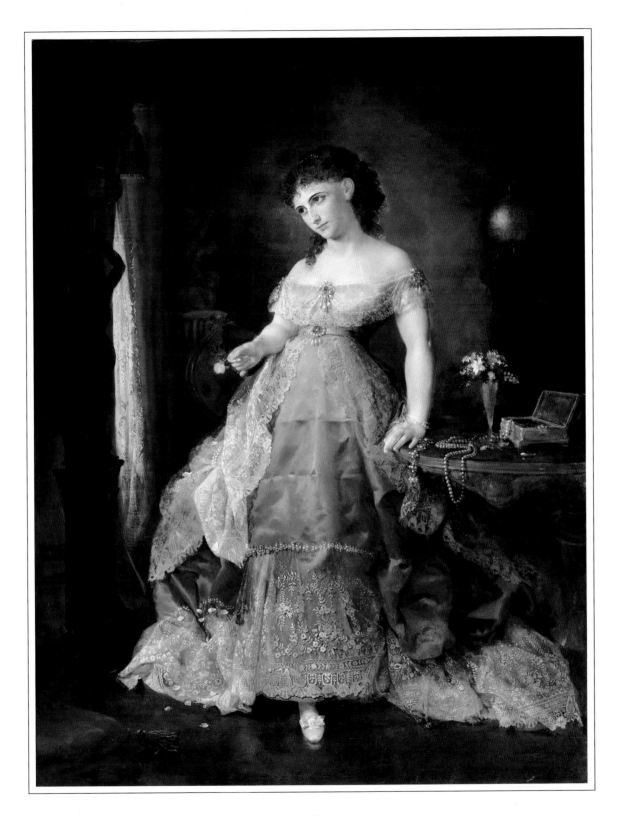

John Rogers. *The Favored Scholar.* Patented 1873.
Cast and painted plaster, 21⅛ x 16⅛ x 12¼".
Gift of John Rogers and Son

TIME IS BUT THE STREAM I GO A-FISHING IN

From Walden

Henry David Thoreau

Time is but the stream I go a-fishing in. I drink at it;
but while I drink I see the sandy bottom and detect
how shallow it is. Its thin current slides away, but
eternity remains. I would drink deeper; fish in the sky,
whose bottom is pebbly with stars. I cannot count one.
I know not the first letter of the alphabet. I have always
been regretting that I was not as wise as the day I was
born. The intellect is a cleaver; it discerns and rifts its
way into the secret of things. I do not wish to be any
more busy with my hands than is necessary. My head is
hands and feet. I feel all my best faculties concentrated
in it. My instinct tells me that my head is an organ for
burrowing, as some creatures use their snout and fore
paws, and with it I would mine and burrow my way
through these hills. I think that the richest vein is
somewhere hereabouts; so by the divining-rod and thin
rising vapors I judge; and here I will begin to mine.

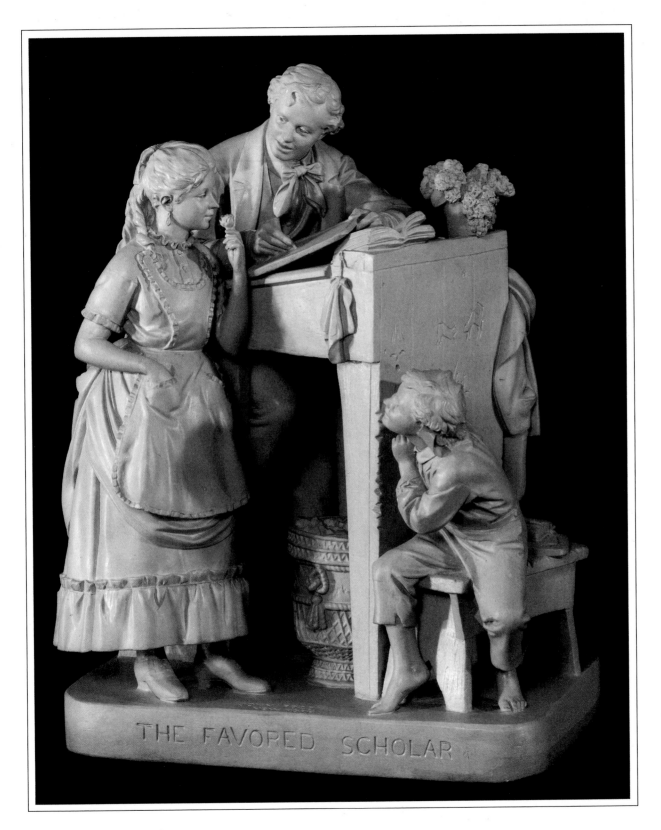

THE FAVORED SCHOLAR

THE GIRL I LEFT BEHIND

Anonymous

SONG LYRICS

There was a wealthy old farmer, who lived in the country nearby,
He had a lovely daughter on whom I cast an eye;
She was pretty, tall and handsome, indeed, so very fair,
There was no other girl in the country with her I could compare.

I asked her if she would be willing for me to cross over the plains,
She said it would make no difference, so I returned again,
She said that she would be true to me till death should prove unkind;
We kissed, shook hands and parted, I left my girl behind.

Out in a western city, boys, a town we all know well,
Where everyone was friendly and to show me all around,
Where work and money was plentiful and the girls to me proved kind,
But the only object on my mind was the girl I left behind.

Eastman Johnson. *The Girl I Left Behind Me.*
1870-75. Oil on canvas, 42 x 34⅞″. Museum
purchase made possible in part by Mrs. Alex-
ander Hamilton Rice in memory of her husband
and by R. C. Johnson

AS ADAM EARLY IN THE MORNING

Walt Whitman

As Adam early in the morning,
Walking forth from the bower refresh'd with sleep,
Behold me where I pass, hear my voice, approach,
Touch me, touch the palm of your hand to my body as I pass,
Be not afraid of my body.

John La Farge. *The Golden Age.*
1878. Oil on canvas, 34⅝ x
16½". Gift of John Gellatly

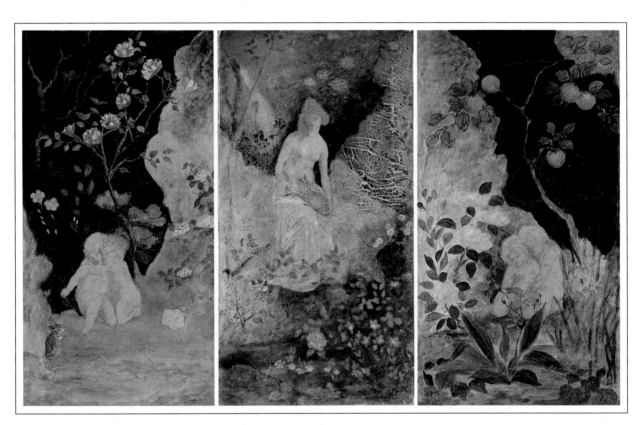

Albert Pinkham Ryder. Panels for a screen:
Children and a Rabbit, *Female Figure*, and *Children
Playing with a Rabbit*. c. 1876–78. Oil on leather;
each panel, 38½ x 20¼". Gift of John Gellatly

MY PLAYMATE

John Greenleaf Whittier

The pines were dark on Ramoth hill,
 Their song was soft and low;
The blossoms in the sweet May wind
 Were falling like the snow.

The blossoms drifted at our feet,
 The orchard birds sang clear;
The sweetest and the saddest day
 It seemed of all the year.

.

I wonder if she thinks of them,
 And how the old time seems;
If ever the pines of Ramoth wood
 Are sounding in her dreams.

I see her face, I hear her voice:
 Does she remember mine?
And what to her is now the boy
 Who fed her father's kine?

What cares she that the orioles build
 For other eyes than ours;
That other hands with nuts are filled,
 And other laps with flowers?

O playmate in the golden time,
 Our mossy seat is green,
Its fringing violets blossom yet,
 The old trees o'er it lean.

The winds so sweet with birch and fern
 A sweeter memory blow;
And there in spring the veeries sing
 The song of long ago.

And still the pines of Ramoth wood
 Are moaning like the sea—
The moaning of the sea of change
 Between myself and thee!

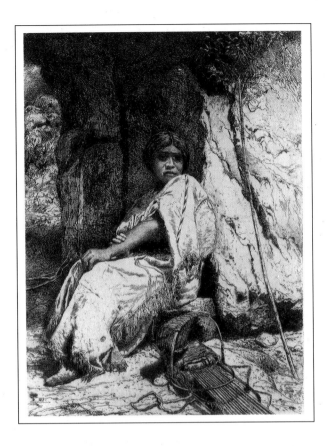

REVELATION
Robert Frost

We make ourselves a place apart
 Behind light words that tease and flout,
But oh, the agitated heart
 Till someone really find us out.

'Tis pity if the case require
 (Or so we say) that in the end
We speak the literal to inspire
 The understanding of a friend.

But so with all, from babes that play
 At hide-and-seek to God afar,
So all who hide too well away
 Must speak and tell us where they are.

INDIANS ARE CURIOUS OBSERVERS
From A Tour on the Prairies
Washington Irving

They are curious observers, noting everything in silence, but with a keen and watchful eye; occasionally exchanging a glance or a grunt with each other, when anything particularly strikes them; but reserving all comments until they are alone. Then it is that they give full scope to criticism, satire, mimicry, and mirth.

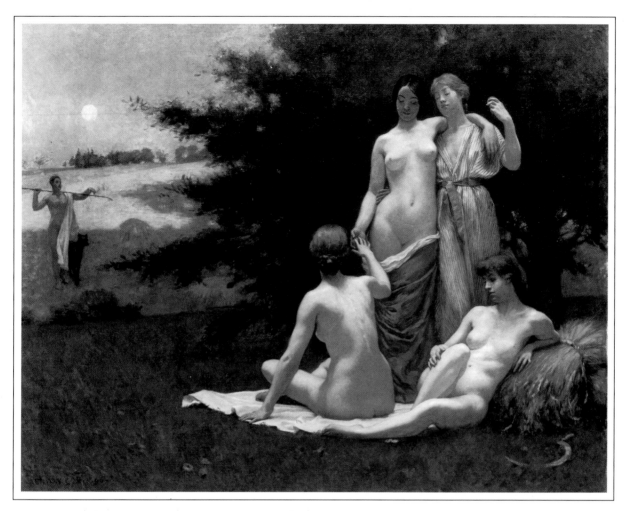

Kenyon Cox. *An Eclogue.* 1890. Oil on canvas, 48 x 60½″. Gift of Allyn Cox

THE DAY IS DONE
Henry Wadsworth Longfellow

The day is done, and the darkness
 Falls from the wings of Night,
As a feather is wafted downward
 From an eagle in his flight.

I see the lights of the village
 Gleam through the rain and the mist,
And a feeling of sadness comes o'er me
 That my soul cannot resist:

A feeling of sadness and longing,
 That is not akin to pain,
And resembles sorrow only
 As the mist resembles the rain.

Come, read to me some poem,
 Some simple and heartfelt lay,
That shall soothe this restless feeling,
 And banish the thoughts of day.

Not from the grand old masters,
 Not from the bards sublime,
Whose distant footsteps echo
 Through the corridors of Time.

For, like strains of martial music,
 Their mighty thoughts suggest
Life's endless toil and endeavor;
 And to-night I long for rest.

Read from some humbler poet,
 Whose songs gushed from his heart,
As showers from the clouds of summer,
 Or tears from the eyelids start;

Who, through long days of labor,
 And nights devoid of ease,
Still heard in his soul the music
 Of wonderful melodies.

Such songs have power to quiet
 The restless pulse of care,
And come like the benediction
 That follows after prayer.

Then read from the treasured volume
 The poem of thy choice,
And lend to the rhyme of the poet
 The beauty of thy voice.

And the night shall be filled with music,
 And the cares, that infest the day,
Shall fold their tents, like the Arabs,
 And as silently steal away.

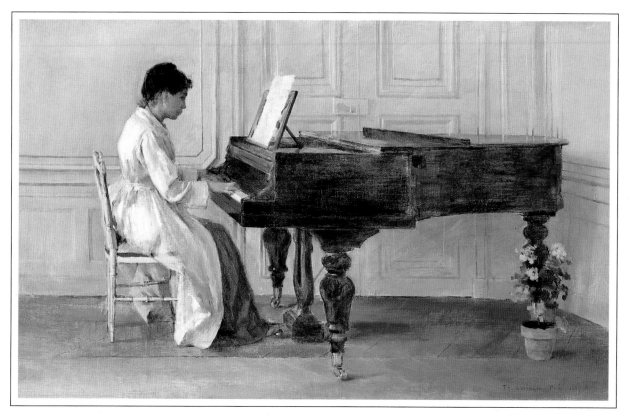

Theodore Robinson. *At the Piano.* 1887. Oil on canvas, 16½ x 25¼″. Gift of John Gellatly

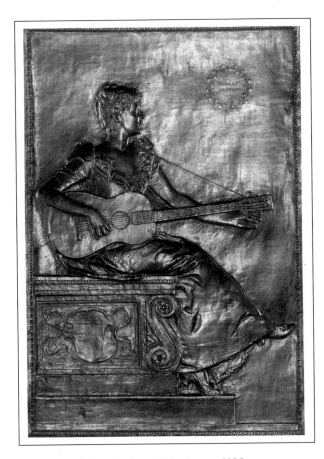

Augustus Saint-Gaudens. *Violet Sargent.* 1890.
Bronze relief, 50 x 34″. Gift of Rose Pitman
Hughes

SAILING IN THE BOAT

Anonymous
SONG LYRICS

Sailing in the boat when the tide runs high,
Waiting for the pretty girl to come by'm by.

CHORUS:
Here she comes, so fresh and fair,
Sky-blue eyes and curly hair,
Rosy in cheek, dimple in her chin,
Say, young man, but you can't come in.

Rose in the garden for you, young man,
Rose in the garden, get it if you can,
But take care not a frost-bitten one.

Choose your partner, stay till day,
And don't never mind what the old folks say.

Old folks say 'tis the very best way
To court all night and sleep all day.

THE NOBILITY OF WOMANHOOD
From "The Titaness"
Thomas Beer

Miss Grace Ralston caught the words from air about her and made use of "the nobility of womanhood" to a courtly, charming gentleman in a Bostonian drawing-room. "Just what," he asked the girl, "is the nobility of womanhood?" Miss Ralston was annoyed. She had in her possession a dried rose once the property of Elizabeth Stanton and some letters from Lucy Stone. The nobility of womanhood was . . . why, it was the nobility of womanhood! The pleasant gentleman seemed amazingly dull. What precisely was the nobility of womanhood? Miss Ralston had to lecture him stringently. The nobility of womanhood meant the nobility of womanhood! Anybody knew that! "Yes," said William James, "but just what is it, my dear?"

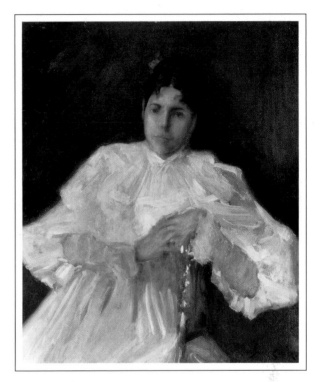

William Merritt Chase. *Girl in White.* c. 1890. Oil on canvas, 30⅝ x 25½". Gift of Mrs. Howard Weingrow

THERE IS A MORN BY MEN UNSEEN

Emily Dickinson

There is a morn by men unseen,
Whose maids upon remoter green
Keep their seraphic May,
And all day long, with dance and game
And gambol I may never name,
Employ their holiday.

Here to light measure move the feet
Which walk no more the village street
Nor by the wood are found;
Here are the birds that sought the sun
When last year's distaff idle hung
And summer's brows were bound.

Ne'er saw I such a wondrous scene,
Ne'er such a ring on such a green,
Nor so serene array—
As if the stars some summer night
Should swing their cups of chrysolite
And revel till the day.

Like thee to dance, like thee to sing,
People upon that mystic green,
I ask each new May morn.
I wait thy far, fantastic bells
Announcing me in other dells
Unto the different dawn!

Frank Weston Benson. *Summer.*
1890. Oil on canvas, 50⅛ x 40″.
Gift of John Gellatly

34

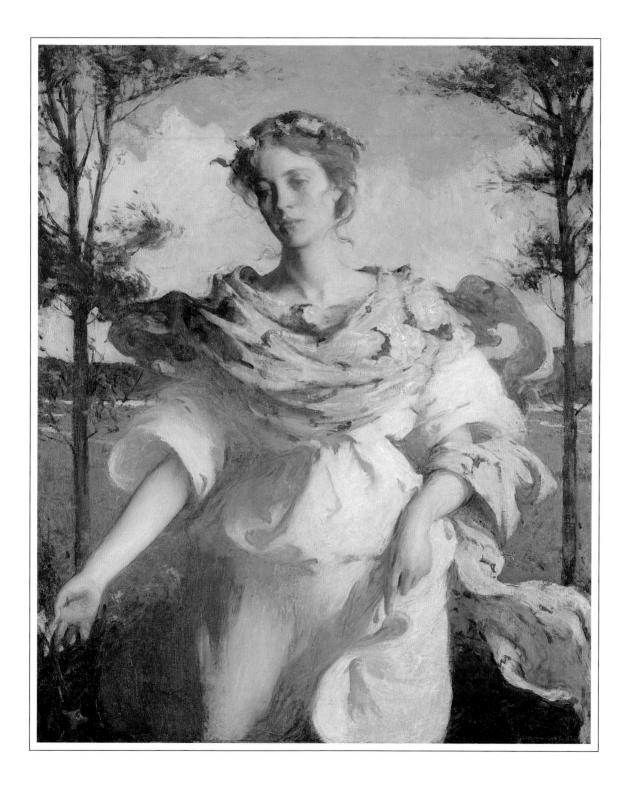

THE FAVORITE FLOWER
Celia Thaxter

Childe Hassam. *Isle of Shoals Garden* or *The Garden in Its Glory.* 1892. Watercolor on paper, $19^{15}/_{16} \times 13^{7}/_{8}''$. Gift of John Gellatly

O the warm, sweet, mellow summer noon,
 The golden calm and the perfumed air,
The chirp of birds and the locust's croon,
 The rich flowers blossoming still and fair.
The old house lies 'mid the swarming leaves
Steeped in sunshine from porch to eaves,
With doors and windows thrown open wide
To welcome the beauty and bloom outside.

Through the gateway and down the walk,
 Madge and grandmother, hand in hand
Come with laughter and happy talk,
 And here by the marigolds stop and stand.
"What a dear old pleasant place it is!"
Cries the little maid in a trance of bliss,
"Never anywhere could be found
So sweet a garden the whole world round!

"Tell me, grandmother, which do you think,
 Is the dearest flower for you that grows!
The phlox, or the marigold stars that wink,
 Or the larkspur quaint, or the red, red rose?
Which do you love best, grandmother dear?"
And the old dame smiles in the blue eyes clear—
"Of all the flowers I ever possessed,
I think, my precious, I love you best!"

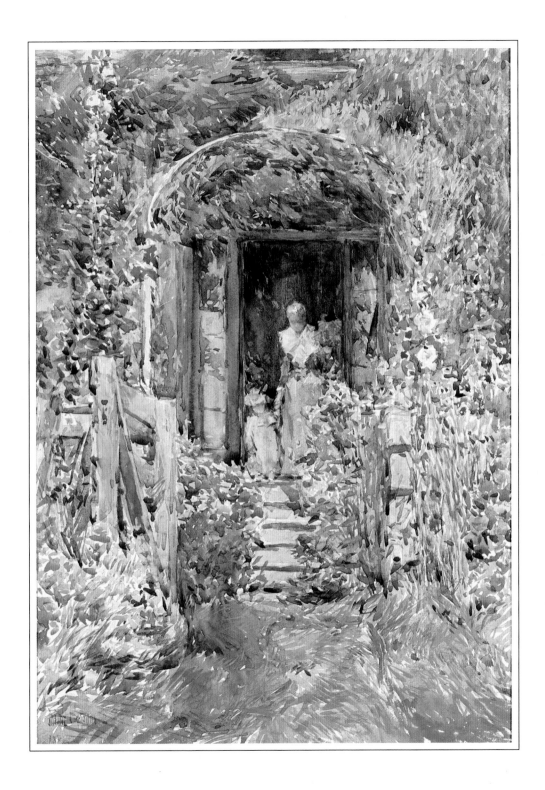

SHE SAW AS SHE HAD NEVER SEEN BEFORE

From The Wings of the Dove

Henry James

The number of new things our young lady looked out on from the high south window that hung over the Park—this number was so great (though some of the things were only old ones altered and, as the phrase was of other matters, done up), that life at present turned to her view from week to week more and more the face of a striking and distinguished stranger. She had reached a great age—for it quite seemed to her that at twenty-five it was late to reconsider; and her most general sense was a shade of regret that she had not known earlier. The world was different—whether for worse or for better—from her rudimentary readings, and it gave her the feeling of a wasted past. If she had only known sooner she might have arranged herself more to meet it. She made, at all events, discoveries every day, some of which were about herself and others about other persons. . . . She saw as she had never seen before how material things spoke to her. She saw, and she blushed to see, that if, in contrast with some of its old aspects, life now affected her as a dress successfully "done up," this was exactly by reason of the trimmings and lace, was a matter of ribbons and silk and velvet. She had a dire accessibility to pleasure from such sources. She liked the charming quarters her aunt had assigned her—liked them literally more than she had in all her other days liked anything; and nothing could have been more uneasy than her suspicion of her relative's view of this truth.

John Singer Sargent. *Elizabeth Winthrop Chanler (Mrs. John Jay Chapman)*. 1893. Oil on canvas, 49⅜ x 40½". Gift of Chanler A. Chapman. Following her marriage in 1898, the subject was known as Mrs. John Jay Chapman.

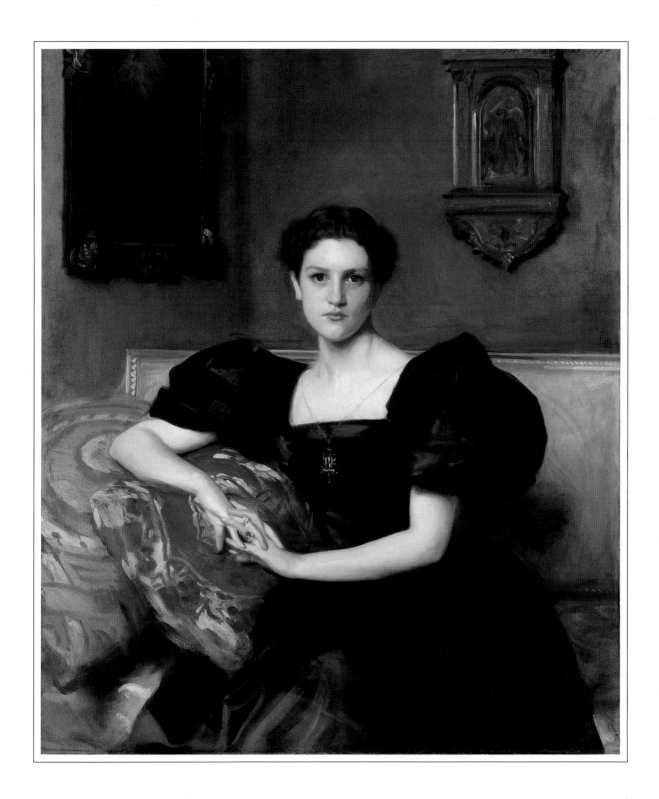

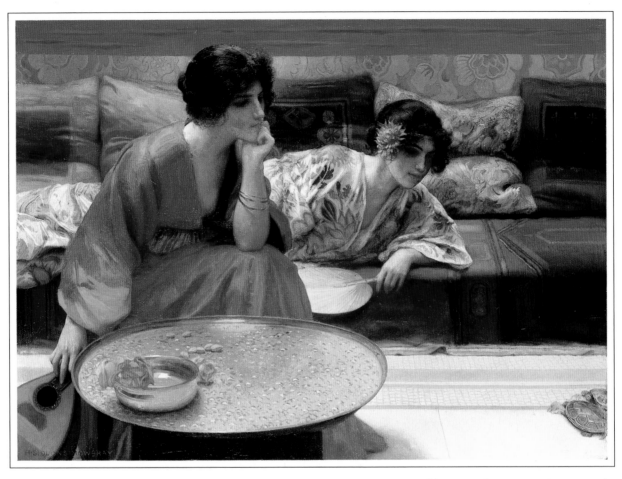

Harry Siddons Mowbray. *Idle Hours.* 1895. Oil
on canvas, 12 x 16″. Gift of William T. Evans

AN IMMORTALITY

Ezra Pound

Sing we for love and idleness,
Naught else is worth the having.

Though I have been in many a land,
There is naught else in living.

And I would rather have my sweet,
Though rose-leaves die of grieving,

Than do high deeds in Hungary
To pass all men's believing.

OCTOBER
Robert Frost

O hushed October morning mild,
Thy leaves have ripened to the fall;
Tomorrow's wind, if it be wild,
Should waste them all.
The crows above the forest call;
Tomorrow they may form and go.
O hushed October morning mild,
Begin the hours of this day slow.
Make the day seem to us less brief.
Hearts not averse to being beguiled,
Beguile us in the way you know.
Release one leaf at break of day;
At noon release another leaf;
One from our trees, one far away.
Retard the sun with gentle mist;
Enchant the land with amethyst.
Slow, slow!
For the grapes' sake, if they were all,
Whose leaves already are burnt with frost,
Whose clustered fruit must else be lost—
For the grapes' sake along the wall.

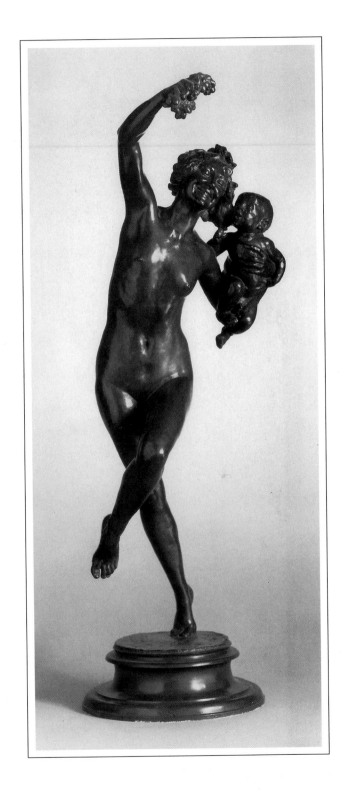

Frederick William MacMonnies. *Bacchante and Infant Faun.* 1894. Bronze, 34 x 10¾ x 14½".
Museum purchase

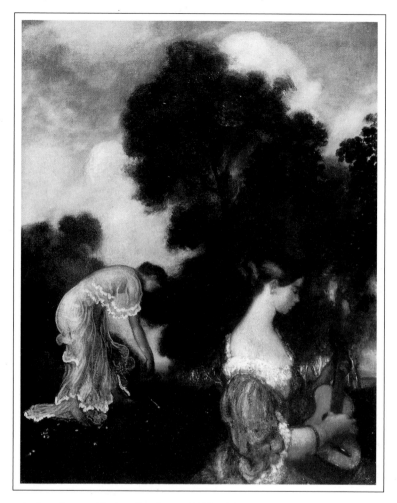

Arthur Bowen Davies. *Evensong*. c. 1898. Oil on canvas,
22 x 17". Gift of John Gellatly

I'M TROUBLED

Anonymous
SONG LYRICS

I'm troubled, I'm troubled,
I'm troubled in my mind,
If trouble don't kill me,
I'll live a long time.

My cheeks was as red,
As the red, red rose,
But now they're as pale as
The lily that blows.

I'll build me a cabin
On the mountain so high,
Where the wild birds can't see me
Or hear my sad cry.

I'm sad and I'm lonely,
My heart it will break,
My true love loves another,
Lord, I wisht I was dead.

BEAUTY
Elinor Wylie

Say not of Beauty she is good,
Or aught but beautiful,
Or sleek to doves' wings of the wood
Her wild wings of a gull.

Call her not wicked; that word's touch
Consumes her like a curse;
But love her not too much, too much,
For that is even worse.

O, she is neither good nor bad,
But innocent and wild!
Enshrine her and she dies, who had
The hard heart of a child.

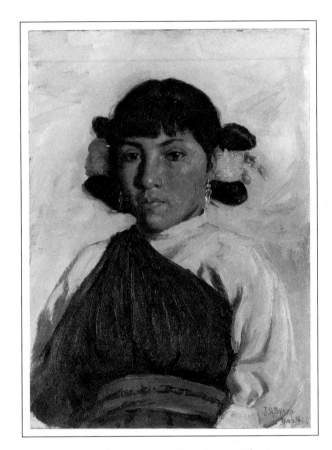

Joseph Henry Sharp. *Do-Ree-Tah.* c. 1900. Oil
on paperboard, 13⅝ x 9¾″. Museum purchase

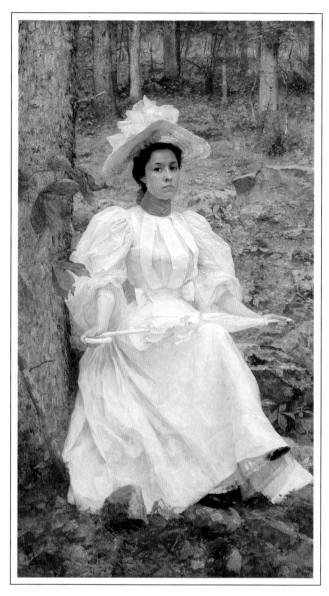

William Robinson Leigh. *Sophie Hunter Colston.* 1896.
Oil on canvas, 72⅜ x 40⅞″. Museum purchase

A DREAM PANG
Robert Frost

I had withdrawn in forest, and my song
Was swallowed up in leaves that blew alway;
And to the forest edge you came one day
(This was my dream) and looked and pondered long,
But did not enter, though the wish was strong:
You shook your pensive head as who should say,
"I dare not—too far in his footsteps stray—
He must seek me would he undo the wrong."

Not far, but near, I stood and saw it all,
Behind low boughs the trees let down outside;
And the sweet pang it cost me not to call
And tell you that I saw does still abide.
But 'tis not true that thus I dwelt aloof,
For the wood wakes, and you are here for proof.

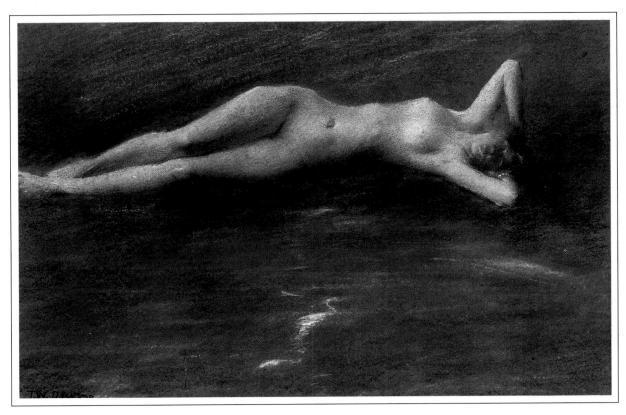

Thomas Dewing. *Reclining Nude Figure of a Girl.*
n.d. Pastel on paper mounted on paperboard,
7 x 10½″. Gift of John Gellatly

FULL OF HER LONG WHITE ARMS
From "The Equilibrists"
John Crowe Ransom

Full of her long white arms and milky skin
He had a thousand times remembered sin.
Alone in the press of people traveled he,
Minding her jacinth, and myrrh, and ivory.

Mouth he remembered: the quaint orifice
From which came heat that flamed upon the kiss,
Till cold words came down spiral from the head,
Grey doves from the officious tower illsped.

Body: it was a white field ready for love,
On her body's field, with the gaunt tower above,
The lilies grew, beseeching him to take,
If he would pluck and wear them, bruise and break.

Eyes talking: Never mind the cruel words,
Embrace my flowers, but not embrace the swords.
But what they said, the doves came straightway flying
And unsaid: Honor, Honor, they came crying.

45

THE SANDPIPER
Celia Thaxter

Across the narrow beach we flit,
 One little sandpiper and I,
And fast I gather, bit by bit,
 The scattered driftwood bleached and dry.
The wild waves reach their hands for it,
 The wild wind raves, the tide runs high,
As up and down the beach we flit,—
 One little sandpiper and I.

Above our heads the sullen clouds
 Scud black and swift across the sky;
Like silent ghosts in misty shrouds
 Stand out the white lighthouses high.
Almost as far as eye can reach
 I see the close-reefed vessels fly,
As fast we flit along the beach,—
 One little sandpiper and I.

I watch him as he skims along,
 Uttering his sweet and mournful cry.
He starts not at my fitful song,
 Or flash of fluttering drapery.
He has no thought of any wrong;
 He scans me with a fearless eye,
Stanch friends are we, well tried and strong,
 The little sandpiper and I.

Comrade, where wilt thou be to-night
 When the loosed storm breaks furiously?
My driftwood fire will burn so bright!
 To what warm shelter canst thou fly?
I do not fear for thee, though wroth
 The tempest rushes through the sky:
For are we not God's children both,
 Thou, little sandpiper and I?

Mary Cassatt. *Sara in a Green Bonnet.* c. 1901. Oil
on canvas, 16⅝ x 13⅝". Gift of John Gellatly

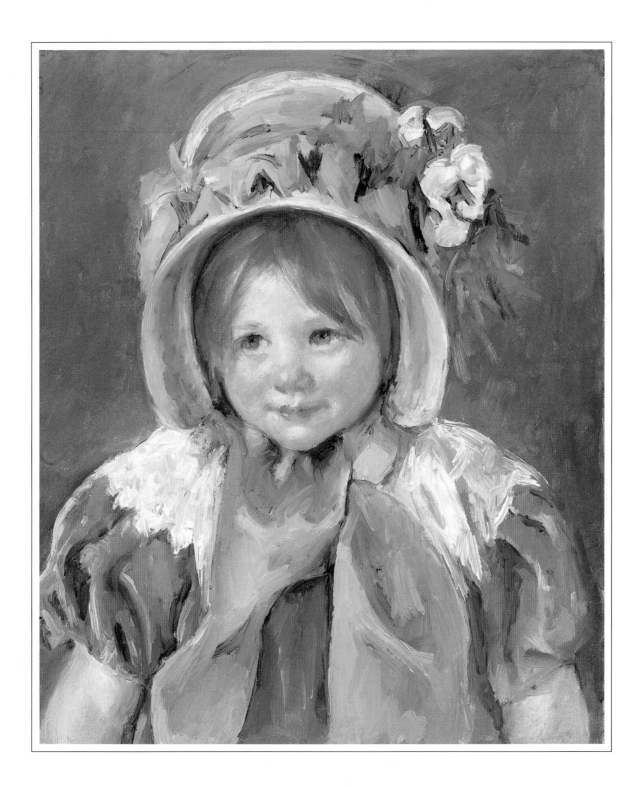

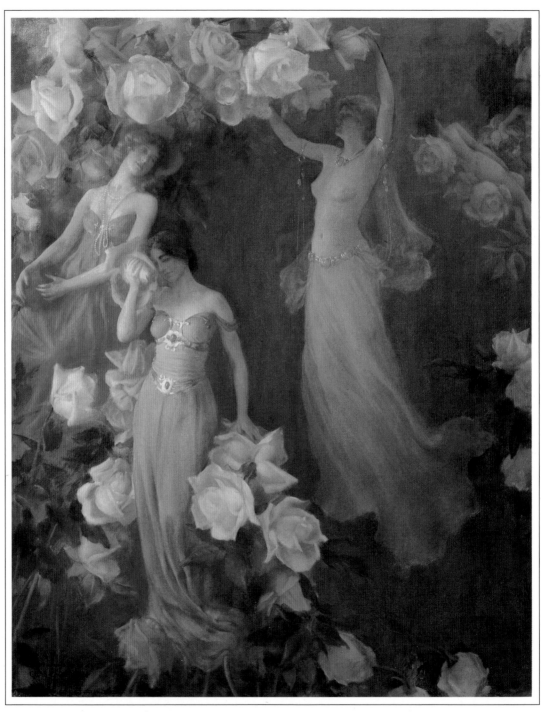

Charles Courtney Curran. *The Perfume of Roses.* 1902. Oil on canvas, 29¼ x 23⅜". Gift of William T. Evans

ROSES ONLY
Marianne Moore

You do not seem to realize that beauty is a liability
 rather
 than an asset—that in view of the fact that spirit
 creates form we are justified in supposing
 that you must have brains. For you, a symbol of the unit,
 stiff and sharp,
 conscious of surpassing by dint of native superiority
 and liking for everything
self-dependent, anything an

ambitious civilization might produce: for you, unaided,
 to attempt through sheer
 reserve, to confuse presumptions resulting from observation,
 is idle. You cannot make us
 think you a delightful happen-so. But rose, if you are
 brilliant, it
 is not because your petals are the without-which-nothing
 of pre-eminence. Would you not, minus
thorns, be a what-is-this, a mere

peculiarity? They are not proof against a worm, the elements,
 or mildew;
 but what about the predatory hand? What is brilliance
 without co-ordination? Guarding the
 infinitesimal pieces of your mind, compelling audience
 to
 the remark that it is better to be forgotten than to be remembered
 too violently,
your thorns are the best part of you.

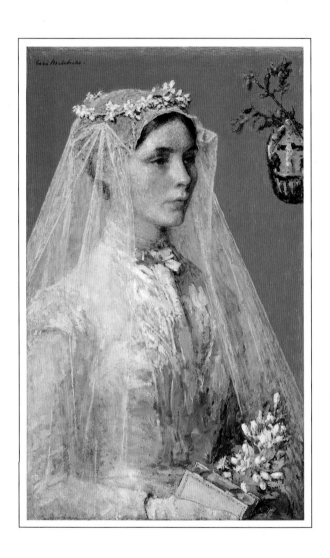

ON MY FORTHCOMING MARRIAGE TO FANNY
From The Tree of Life
Hugh Nissenson

Tomorrow, I will start
With thee
A journey on the flood-tide
Of my heart.

Thou art water
Fit to drink,
Fresh bread,
The North
That stopped the arrow
Spinning in my head.

Gari Melchers. *The Bride.* c. 1907.
Oil on canvas, 27⅝ x 16½".
Gift of John Gellatly

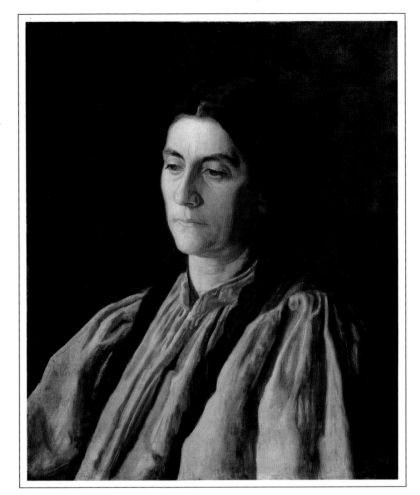

Thomas Eakins. *Mother (Annie Williams Gandy)*.
c. 1903. Oil on canvas, 24 x 20″. Bequest of
Mrs. Edward Pearson Rodman

NOW THAT LILACS ARE IN BLOOM
From "Portrait of a Lady"
T. S. Eliot

Now that lilacs are in bloom
She has a bowl of lilacs in her room
And twists one in her fingers while she talks.
"Ah, my friend, you do not know, you do not know
What life is, you who hold it in your hands";
(Slowly twisting the lilac stalks)

"You let it flow from you, you let it flow,
And youth is cruel, and has no remorse
And smiles at situations which it cannot see."
I smile, of course,
And go on drinking tea.
"Yet with these April sunsets, that somehow recall
My buried life, and Paris in the Spring,
To be wonderful and youthful, after all."
To be wonderful and youthful, after all."

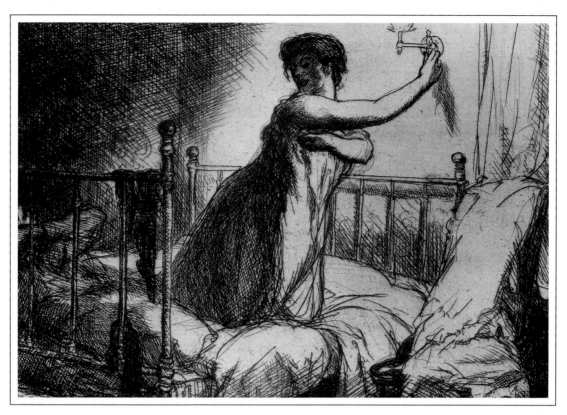

John Sloan. *Turning Out the Light*, from the series *New York City Life*.
1905. Etching on paper, 5 x 7″. Bequest of Frank McClure

GIRL IN A NIGHTGOWN
Wallace Stevens

Lights out. Shades up.
A look at the weather.
There has been a booming all the spring,
A refrain from the end of the boulevards.

This is the silence of night,
This is what could not be shaken,
Full of stars and the images of stars—
And that booming wintry and dull,

Like a tottering, a falling and an end,
Again and again, always there,
Massive drums and leaden trumpets,
Perceived by feeling instead of sense,

A revolution of things colliding.
Phrases! But of fear and of fate.
The night should be warm and fluters' fortune
Should play in the trees when morning comes.

Once it was, the repose of night,
Was a place, strong place, in which to sleep.
It is shaken now. It will burst into flames,
Either now or tomorrow or the day after that.

William Sergeant Kendall. *An Interlude.* 1907.
Oil on canvas, 44⅛ x 43¼". Gift of William T.
Evans

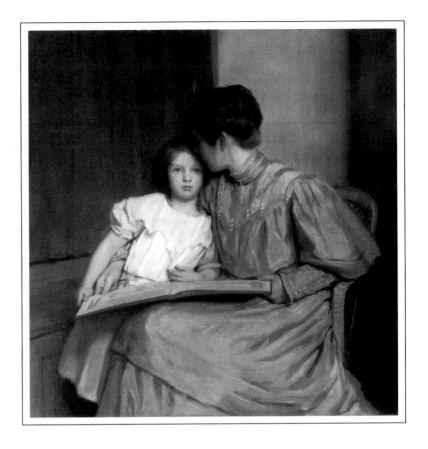

A HEALTHY, WELL-GROWN CHILD
From Washington Square
Henry James

She was a healthy, well-grown child, without a trace of her mother's beauty. She was not ugly; she had simply a plain, dull, gentle countenance. The most that had ever been said for her was that she had a "nice" face; and, though she was an heiress, no one had ever thought of regarding her as a belle. Her father's opinion of her moral purity was abundantly justified; she was excellently, imperturbably good; affectionate, docile, obedient, and much addicted to speaking the truth. In her younger years she was a good deal of a romp, and, though it is an awkward confession to make about one's heroine, I must add that she was something of a glutton. She never, that I know of, stole raisins out of the pantry; but she devoted her pocket-money to the purchase of cream-cakes. As regards this, however, a critical attitude would be inconsistent with a candid reference to the early annals of any biographer. Catherine was decidedly not clever; she was not quick with her book, nor, indeed, with anything else.

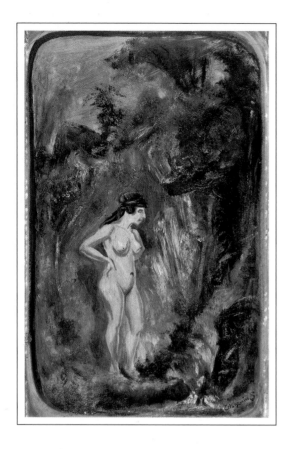

Louis Michel Eilshemius. *Nude in Forest.*
c. 1908–16. Oil on canvas, 11⅞ x 20″. Gift
of Carrol I. Burtanger

SING OF IT WITH MY OWN VOICE
From "Lilacs"
Amy Lowell

Lilacs,
False blue,
White,
Purple,
Colour of lilac.
Heart-leaves of lilac all over New England,
Roots of lilac under all the soil of New England,
Lilac in me because I am New England,
Because my roots are in it,
Because my leaves are of it,
Because my flowers are for it,
Because it is my country
And I speak to it of itself
And sing of it with my own voice
Since certainly it is mine.

BEAUTY IS MOMENTARY IN THE MIND
From "Peter Quince at the Clavier"
Wallace Stevens

Beauty is momentary in the mind—
The fitful tracing of a portal;
But in the flesh it is immortal.

The body dies; the body's beauty lives.
So evenings die, in their green going,
A wave, interminably flowing.
So gardens die, their meek breath scenting
The cowl of Winter, done repenting.
So maidens die to the auroral
Celebration of a maiden's choral.

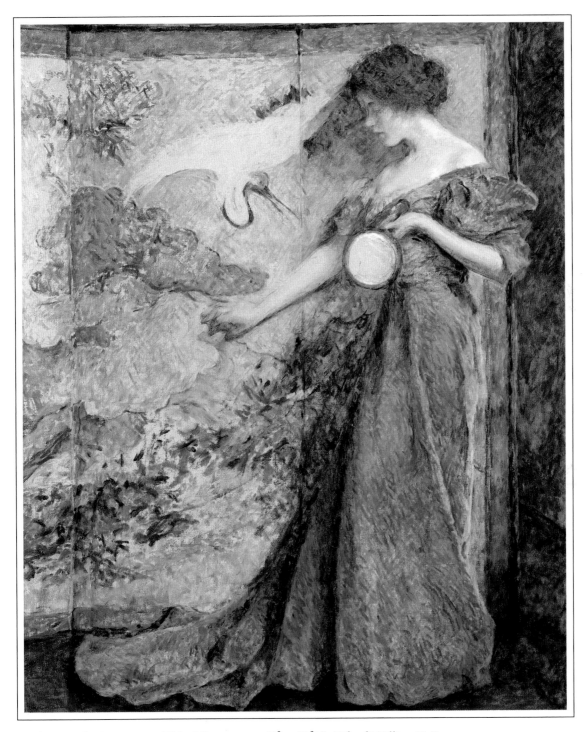

Robert Reid. *The Mirror.* c. 1910. Oil on canvas, 37³⁄₈ x 30³⁄₈". Gift of William T. Evans

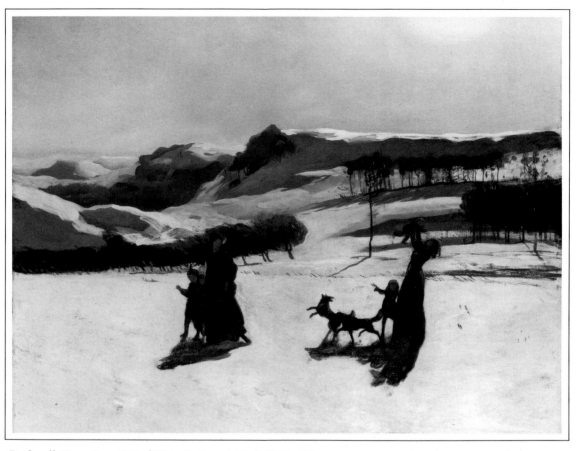

Rockwell Kent. *Snow Fields (Winter in the Berkshires)*. 1909. Oil on canvas mounted on linen, 38 x 44″.
Bequest of Henry Ward Ranger through the National Academy of Design

THE BIRTHPLACE

Robert Frost

Here further up the mountain slope
Than there was ever any hope,
My father built, enclosed a spring,
Strung chains of wall round everything,
Subdued the growth of earth to grass,

And brought our various lives to pass.
A dozen girls and boys we were.
The mountain seemed to like the stir,
And made of us a little while—
With always something in her smile.
Today she wouldn't know our name.
(No girl's, of course, has stayed the same.)
The mountain pushed us off her knees.
And now her lap is full of trees.

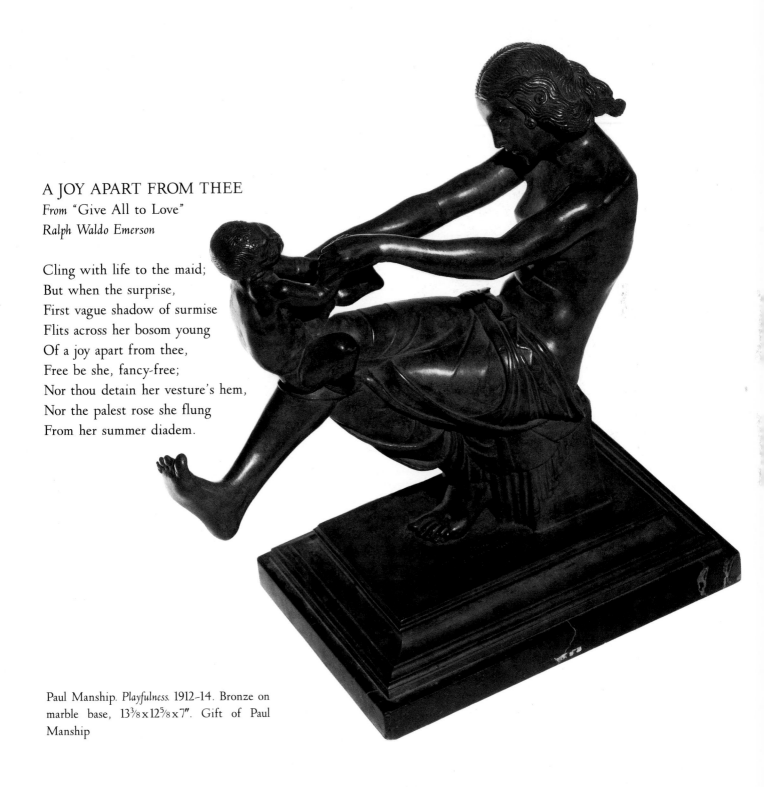

A JOY APART FROM THEE
From "Give All to Love"
Ralph Waldo Emerson

Cling with life to the maid;
But when the surprise,
First vague shadow of surmise
Flits across her bosom young
Of a joy apart from thee,
Free be she, fancy-free;
Nor thou detain her vesture's hem,
Nor the palest rose she flung
From her summer diadem.

Paul Manship. *Playfulness.* 1912–14. Bronze on marble base, 13⅜ x 12⅝ x 7". Gift of Paul Manship

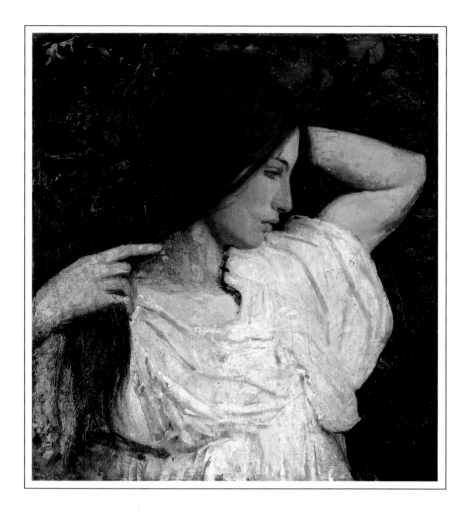

Abbott Handerson Thayer. *Girl Arranging Her Hair.* 1918–19. Oil on canvas, 25⅝ x 24¼". Gift of John Gellatly

SOMETHING DARK AND UNKNOWN
From Look Homeward, Angel
Thomas Wolfe

He was devoured by a vast strange hunger for life. At night, he listened to the million-noted ululation of little night things, the great brooding symphony of dark, the ringing of remote churchbells across the country. And his vision widened out in circles over moon-drenched meadows, dreaming woods, mighty rivers going along in darkness, and ten thousand sleep-ing towns. He believed in the infinite rich variety of all the towns and faces: behind any of a million shabby houses he believed there was strange buried life, subtle and shattered romance, something dark and unknown. At the moment of passing any house, he thought, some one therein might be at the gate of death, lovers might lie twisted in hot embrace, murder might be doing.

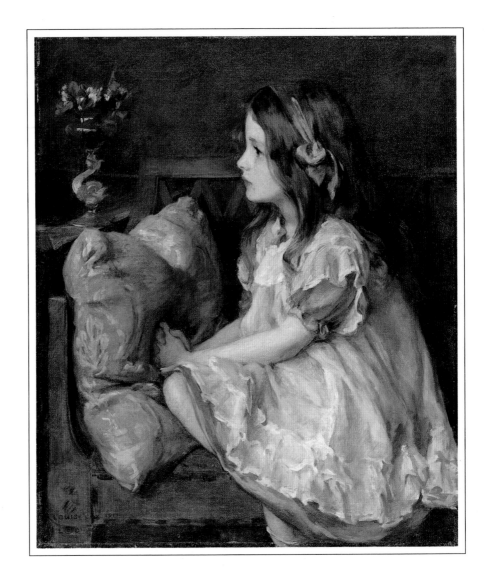

Louise Howland King Cox.
May Flowers. 1911. Oil on
canvas, 24⅛ x 20⅛". Gift of
William T. Evans

FAIR ARE THE FLOWERS
From "Indirection"
Richard Realf

Fair are the flowers and the children, but their subtle suggestion is fairer;
Rare is the roseburst of dawn, but the secret that clasps it is rarer;
Sweet the exultance of song, but the strain that precedes it is sweeter;
And never was poem yet writ, but the meaning outmastered the metre.

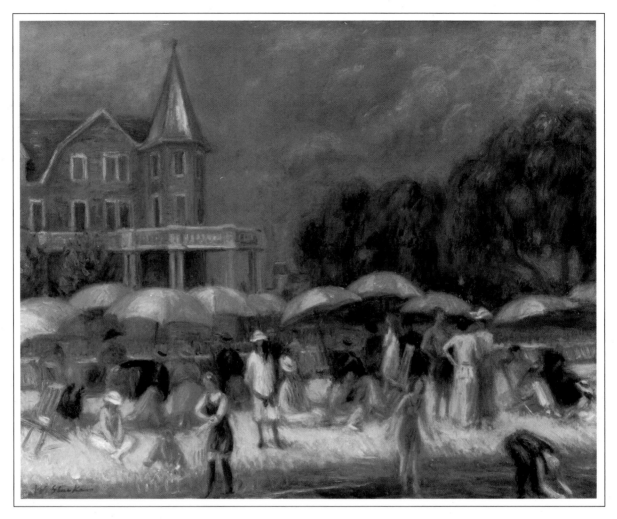

William J. Glackens. *Beach Umbrellas at Blue Point.* c. 1915. Oil on canvas, 26 x 32″. Gift of Mr. and Mrs. Ira Glackens

CHILDREN OF THE EARTH
From "On the Beach"
Celia Thaxter

The slow, cool, emerald breakers cruising clear
Along the sparkling edge of level sand,
Shatters its crystal arch, and far and near

Its broken splendor spills upon the land.
With rush and whisper, siren sweet and soft
Gently salutes the children of the earth,
And catches every sunbeam from aloft,
Flashes it back in summer mood of mirth:
And with its flood of strong refreshment pours
Health and delight along the sounding shores.

A VIRGINAL
Ezra Pound

No, no! Go from me. I have left her lately.
I will not spoil my sheath with lesser brightness,
For my surrounding air hath a new lightness;
Slight are her arms, yet they have bound me straitly
And left me cloaked as with a gauze of aether;
As with sweet leaves; as with subtle clearness.
Oh, I have picked up magic in her nearness
To sheathe me half in half the things that sheathe her.
No, no! Go from me. I have still the flavour,
Soft as spring wind that's come from birchen bowers.
Green come the shoots, aye April in the branches,
As winter's wound with her sleight hand she staunches,
Hath of the trees a likeness of the savour:
As white their bark, so white this lady's hours.

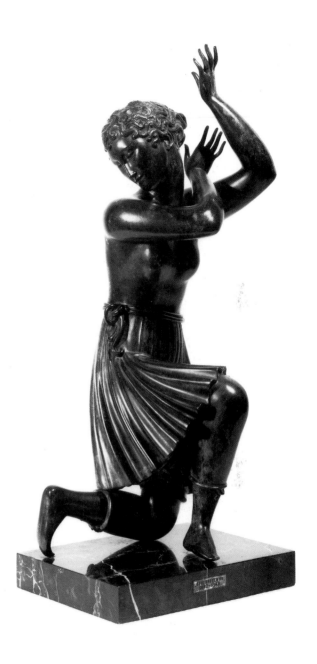

Elie Nadelman. *Dancer.* c. 1916–18.
Bronze on marble base, 31⅜ x 13¼ x
11½″. Gift of Countess Helen Naselli

I WALK DOWN THE GARDEN PATHS

From "Patterns"

Amy Lowell

I walk down the garden paths,
And all the daffodils
Are blowing, and the bright blue squills.
I walk down the patterned garden-paths
In my stiff, brocaded gown.
With my powdered hair and jewelled fan,
I too am a rare
Pattern. As I wander down
The garden paths.

My dress is richly figured,
And the train
Makes a pink and silver stain
On the gravel, and the thrift
Of the borders.
Just a plate of current fashion,
Tripping by in high-heeled, ribboned shoes.
Not a softness anywhere about me,
Only whalebone and brocade.
And I sink on a seat in the shade
Of a lime tree. For my passion
Wars against the stiff brocade.
The daffodils and squills
Flutter in the breeze
As they please.
And I weep;
For the lime-tree is in blossom
And one small flower has dropped upon my bosom.

And the plashing of waterdrops
In the marble fountain
Comes down the garden-paths.

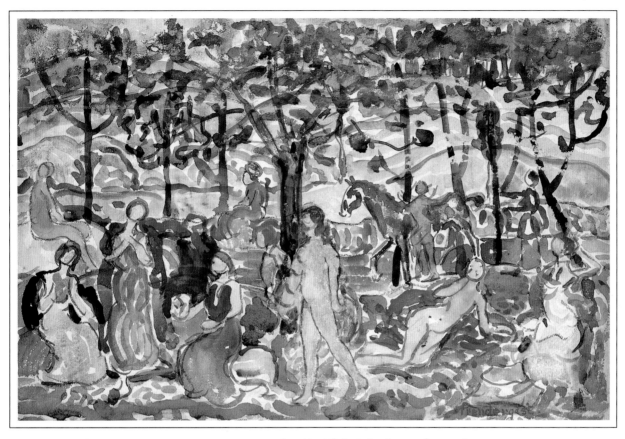

Maurice Brazil Prendergast. *Park Scene.* 1918. Watercolor, 15 x 22⅛″. Gift of Eugenie Prendergast

The dripping never stops.
Underneath my stiffened gown
Is the softness of a woman bathing in a marble basin,
A basin in the midst of hedges grown
So thick, she cannot see her lover hiding,
But she guesses he is near,
And the sliding of the water
Seems the stroking of a dear
Hand upon her.
What is Summer in a fine brocaded gown!
I should like to see it lying in a heap upon the ground.
All the pink and silver crumpled up on the ground.

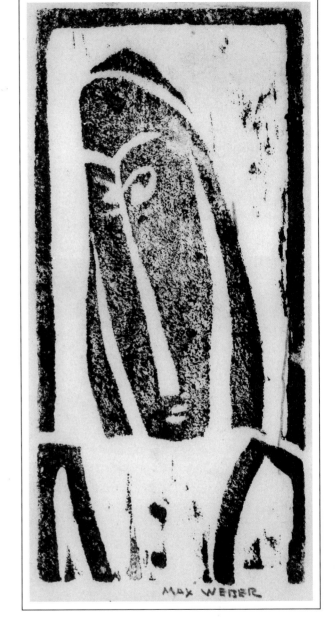

Max Weber. *Head and Shoulders of Figure*. 1919–20. Woodcut on paper, 4⅛ x 2″. Gift of Mr. and Mrs. Harry Baum in memory of Edith Gregor Halpert

MISAPPREHENSION

Paul Laurence Dunbar

Out of my heart, one day, I wrote a song,
 With my heart's blood imbued,
Instinct with passion, tremulously strong,
 With grief subdued;
 Breathing a fortitude
 Pain-bought.
And one who claimed much love for what I wrought,
 Read and considered it,
 And spoke:
"Ay, brother,—'t is well writ,
 But where's the joke?"

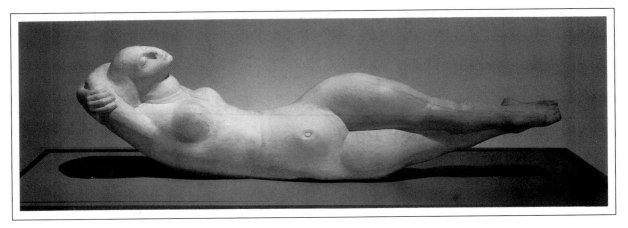

William Zorach. *Floating Figure.* 1922. Cast plaster, 8½ x 32 x 6″. Gift of Tessim Zorach and Dahlov Ipcar

TO EARTHWARD
Robert Frost

Love at the lips was touch
As sweet as I could bear;
And once that seemed too much;
I lived on air

That crossed me from sweet things,
The flow of—was it musk
From hidden grapevine springs
Down hill at dusk?

I had the swirl and ache
From sprays of honeysuckle
That when they're gathered shake
Dew on the knuckle.

I craved strong sweets, but those
Seemed strong when I was young;
The petal of the rose
It was that stung.

Now no joy but lacks salt
That is not dashed with pain
And weariness and fault;
I crave the stain

Of tears, the aftermark
Of almost too much love,
The sweet of bitter bark
And burning clove.

When stiff and sore and scarred
I take away my hand
From leaning on it hard
In grass and sand,

The hurt is not enough:
I long for weight and strength
To feel the earth as rough
To all my length.

65

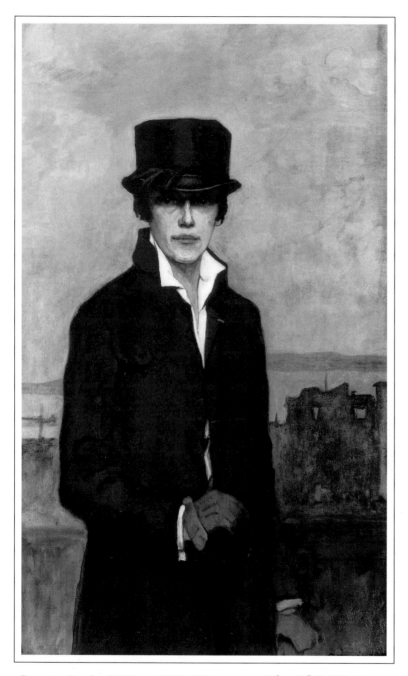

Romaine Brooks. *Self-Portrait.* 1923. Oil on canvas, 46¼ x 26⅞″. Gift of the artist

PASSER MORTUUS EST
Edna St. Vincent Millay

Death devours all lovely things:
 Lesbia with her sparrow
Shares the darkness,—presently
 Every bed is narrow.

Unremembered as old rain
 Dries the sheer libation;
And the little petulant hand
 Is an annotation.

After all, my erstwhile dear,
 My no longer cherished,
Need we say it was not love,
 Just because it perished?

SHE WAS RATHER HANDSOME
From "The Return"
Sherwood Anderson

After he had dined, John went up to his room, and presently the woman followed. The door leading into the hall had been left open, and she came and stood in the doorway. Really, she was rather handsome. She only wanted to be sure that everything was all right, that he had towels and soap and everything he needed.

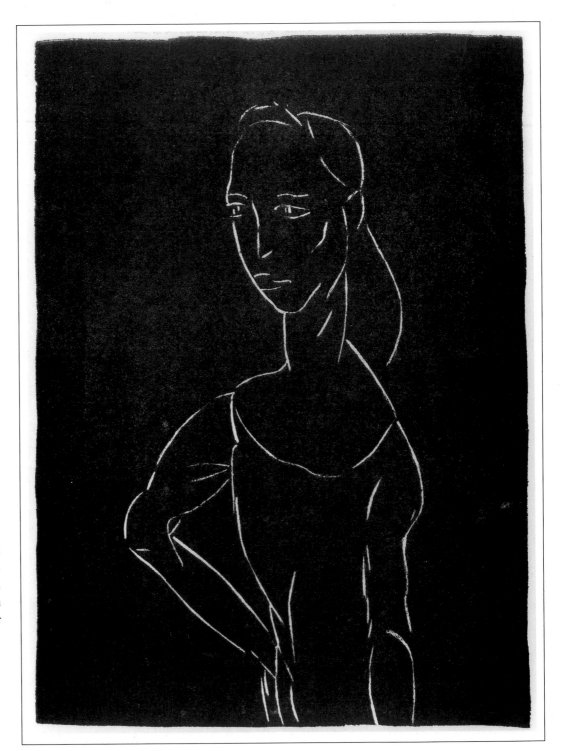

Alfred Henry Maurer. *Standing Figure.* 1924–28. Linoleum cut on paper, 6 5/16 x 4 9/16". Museum purchase, Robert Tyler Davis Memorial Fund

Yasuo Kuniyoshi. *Strong Woman and Child.* 1925.
Oil on canvas, 57⅜ x 44⅞". Gift of the Sara
Roby Foundation

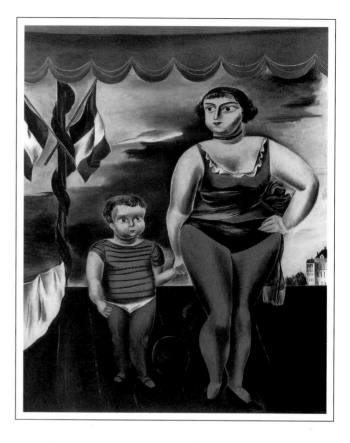

SECRETS OF THE TRADE
From "Japan"
Anthony Hecht

It was a miniature country once
To my imagination: Home of the Short,
And also the academy of stunts
 Where acrobats are taught
 The famous secrets of the trade:
 To cycle in the big parade
While spinning plates upon their parasols,
Or somersaults that do not touch the ground,
 Or tossing seven balls
In Most Celestial Order round and round.

.

Now the quaint early image of Japan
That was so charming to me as a child
Seems like a bright design upon a fan,—
 Of water rushing wild
 On rocks that can be folded up,
 A river which the wrist can stop
With a neat flip, revealing merely sticks
And silk of what had been a fan before,
 And like such winning tricks,
It shall be buried in excelsior.

YOU CAN'T GET AHEAD OF MOTHER

From "The Golden Honeymoon"
Ring Lardner

Mother says that when I start talking I never know when to stop. But I tell her the only time I get a chance is when she ain't around, so I have to make the most of it. I guess the fact is neither one of us would be welcome in a Quaker meeting, but as I tell Mother, what did God give us tongues for if He didn't want we should use them? Only she says He didn't give them to us to say the same thing over and over again, like I do, and repeat myself. But I say:

"Well, Mother," I say, "when people is like you and I and been married fifty years, do you expect everything I say will be something you ain't heard me say before? But it may be new to others, as they ain't nobody else lived with me as long as you have."

So she says:

"You can bet they ain't, as they couldn't nobody else stand you that long."

"Well," I tell her, "you look pretty healthy."

"Maybe I do," she will say, "but I looked even healthier before I married you."

You can't get ahead of Mother.

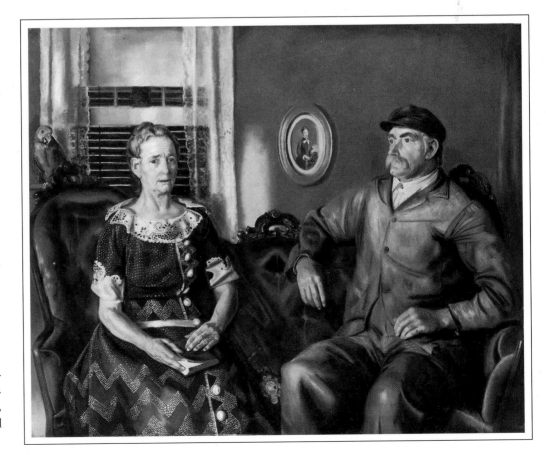

George Wesley Bellows.
Mr. and Mrs. Phillip Wase.
1924. Oil on canvas,
51¼ x 63". Gift of Paul
Mellon

George Luks. *The Polka Dot Dress.* 1927.
Oil on canvas, 58⅛ x 37″. Gift of Mrs.
Howard Weingrow

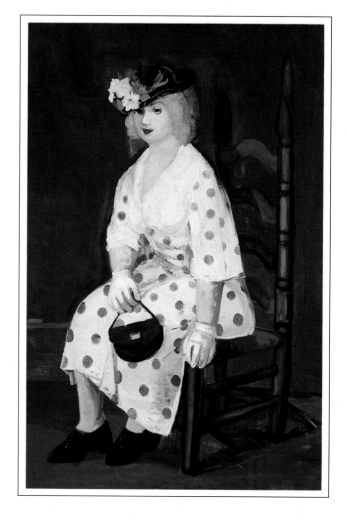

SHE WANTED TO BE MARRIED
From "Big Blonde"
Dorothy Parker

She wanted to be married. She was nearing thirty now, and she did not take the years well. She spread and softened, and her darkening hair turned her to inexpert dabbings with peroxide. There were times when she had little flashes of fear about her job. And she had had a couple of thousand evenings of being a good sport among her male acquaintances. She had come to be more conscientious than spontaneous about it.

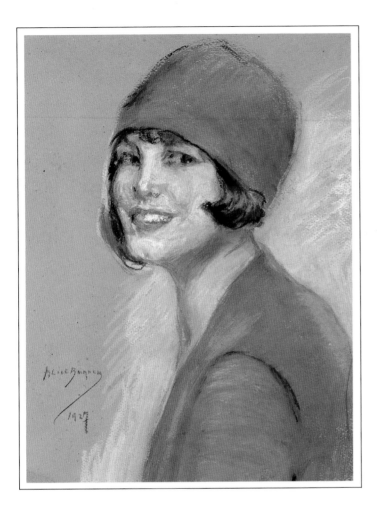

Alice Pike Barney. *Hollywood.* 1927. Pastel on paper, 17⅜ x 13″. Gift of Laura Dreyfus Barney

AN ABSOLUTE ROSE
From The Great Gatsby
F. Scott Fitzgerald

The butler came back and murmured something close to Tom's ear, whereupon Tom frowned, pushed back his chair, and without a word went inside. As if his absence quickened something within her, Daisy leaned forward again, her voice glowing and singing.

"I love to see you at my table, Nick. You remind me of a—of a rose, an absolute rose. Doesn't he?" She turned to Miss Baker for confirmation: "An absolute rose?"

This was untrue. I am not even faintly like a rose. She was only extemporizing, but a stirring warmth flowed from her, as if her heart was trying to come out to you concealed in one of those breathless, thrilling words. Then suddenly she threw her napkin on the table and excused herself and went into the house.

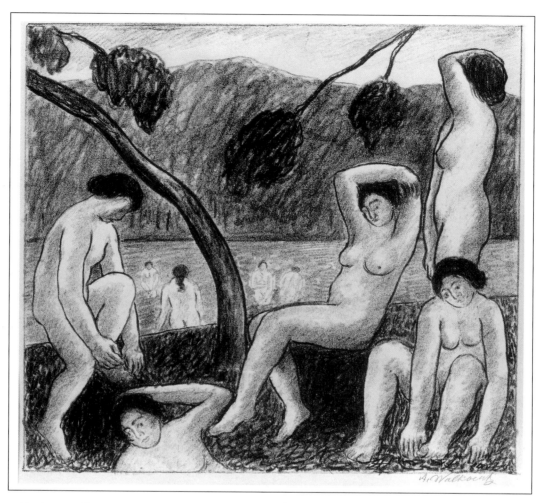

Abraham Walkowitz. *The Bathers.* 1927. Lithograph, 9⅝ x 15¹⁵⁄₁₆″. Museum purchase

ANIMAL
Max Eastman

Could you, so arrantly of earth, so cool,
With coarse harsh hair and rapid agile pace,
So built to beat boys in a swimming race
Or dive with sheer terns to a salty pool,
So lean, so animally beautiful—

Your breasts look sideways like a heifer's face,
And you stand sometimes with a surly grace
And mutinous blue eye-fires like a bull—
Could you from this most envied poise descend,
Moved by some force in me I know not of,
To mix with me and be to me a woman,
Diana down from heaven could not lend
More ecstasy, or fill my faltering human
Heart's hunger with a more celestial love.

EUCLID ALONE HAS LOOKED ON BEAUTY BARE

Edna St. Vincent Millay

Euclid alone has looked on Beauty bare.
Let all who prate of Beauty hold their peace,
And lay them prone upon the earth and cease
To ponder on themselves, the while they stare
At nothing, intricately drawn nowhere
In shapes of shifting lineage; let geese
Gabble and hiss, but heroes seek release
From dusty bondage into luminous air.
O blinding hour, O holy, terrible day,
When first the shaft into his vision shone
Of light anatomized! Euclid alone
Has looked on Beauty bare. Fortunate they
Who, though once only and then but far away,
Have heard her massive sandal set on stone.

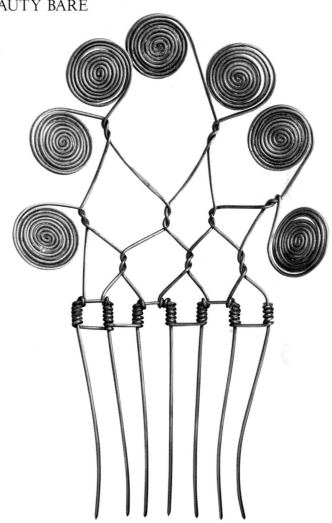

Alexander Calder. *Haircomb.* n.d. Gilded brass,
17 x 11½". Gift of Mr. and Mrs. Alexander
Calder

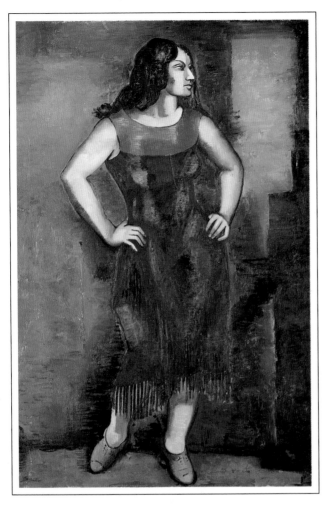

Morris Kantor. *Dancer*. 1928. Oil on linen,
46⅛ x 30⅛". Gift of Mrs. Morris Kantor

THESE ENCOUNTERS WITH BEAUTY
From "My Brother Paul"
Theodore Dreiser

And the results of these encounters with beauty!
Always he had something most important to attend to,
morning, noon or night, and whenever I encountered
him after some such statement "the important thing"
was, of course, a woman. As time went on and he
began to look upon me as something more than a thin,
spindling, dyspeptic and disgruntled youth, he began
to wish to introduce me to some of his marvelous
followers, and then I could see how completely depen-
dent upon beauty in the flesh he was, how it made his
life and world.

OLD MARY
Gwendolyn Brooks

My last defense
Is the present tense.

It little hurts me now to know
I shall not go

Cathedral-hunting in Spain
Nor cherrying in Michigan or Maine.

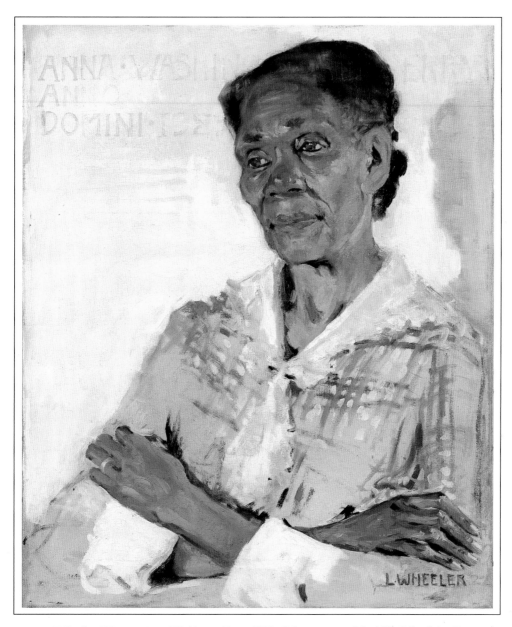

Laura Wheeler Waring. *Anna Washington Derry.* 1927. Oil on canvas, 20 x 16″. Gift of the Harmon Foundation

ONE PERFECT ROSE
Dorothy Parker

A single flow'r he sent me, since we met.
 All tenderly his messenger he chose;
Deep-hearted, pure, with scented dew still wet—
 One perfect rose.

I knew the language of the floweret;
 "My fragile leaves," it said, "his heart enclose."
Love long has taken for his amulet
 One perfect rose.

Why is it no one ever sent me yet
 One perfect limousine, do you suppose?
Ah no, it's always just my luck to get
 One perfect rose.

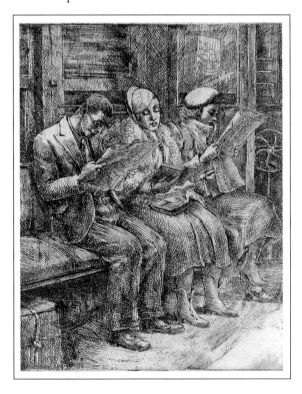

LOVE CALLS US TO THE THINGS OF THIS WORLD
Richard Wilbur

 The eyes open to a cry of pulleys,
And spirited from sleep, the astounded soul
Hangs for a moment bodiless and simple
As false dawn.
 Outside the open window
The morning air is all awash with angels.

 Some are in bed-sheets, some are in blouses,
Some are in smocks: but truly there they are.
Now they are rising together in calm swells
Of halcyon feeling, filling whatever they wear
With the deep joy of their impersonal breathing;

 Now they are flying in place, conveying
The terrible speed of their omnipresence, moving
And staying like white water; and now of a sudden
They swoon down into so rapt a quiet
That nobody seems to be there.
 The soul shrinks

 From all that it is about to remember,
From the punctual rape of every blessèd day,
And cries,
 "Oh, let there be nothing on earth but
 laundry,
Nothing but rosy hands in the rising steam
And clear dances done in the sight of heaven."

Reginald Marsh. *Subway—Three People*. 1934.
Etching on paper, 8¹⁵⁄₁₆ x 7″. Bequest of Frank McClure

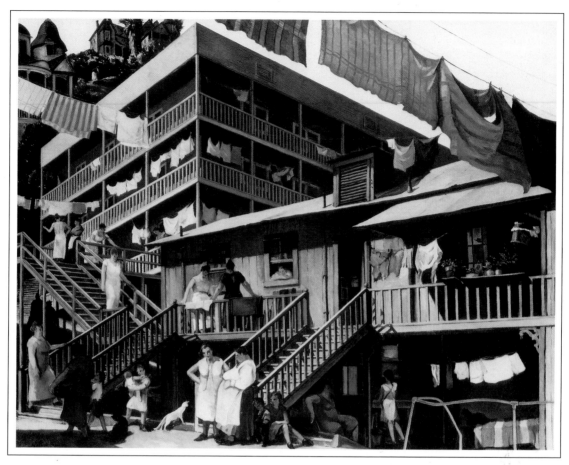

Millard Sheets. *Tenement Flats (Family Flats)*. c. 1934. Oil on canvas, 40¼ x 50¼". Transfer from the U.S. Department of the Interior, National Park Service

Yet, as the sun acknowledges
With a warm look the world's hunks and colors,
The soul descends once more in bitter love
To accept the waking body, saying now
In a changed voice as the man yawns and rises,

"Bring them down from their ruddy gallows;
Let there be clean linen for the backs of thieves;
Let lovers go fresh and sweet to be undone,
And the heaviest nuns walk in a pure floating
Of dark habits,
keeping their difficult balance."

"SUMMERTIME AND THE LIVING . . ."
Robert Hayden

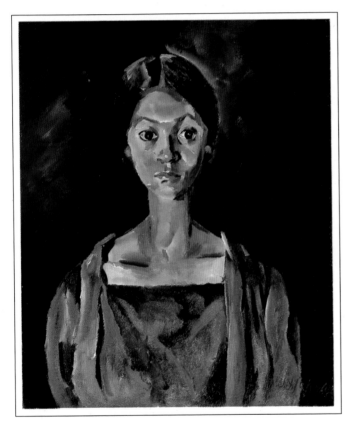

William H. Johnson. *Girl in a Green Dress* or *Portrait Study.* 1930.
Oil on canvas, 24 x 19″. Gift of the Harmon Foundation

Nobody planted roses, he recalls,
but sunflowers gangled there sometimes,
tough-stalked and bold
and like the vivid children there unplanned.
There circus-poster horses curveted
in trees of heaven
above the quarrels and shattered glass,
and he was bareback rider of them all.

No roses there in summer—
oh, never roses except when people died—
and no vacations for his elders,
so harshened after each unrelenting day
that they were shouting-angry.
But summer was, they said, the poor folks' time
of year. And he remembers
how they would sit on broken steps amid

The fevered tossings of the dusk, the dark,
wafting hearsay with funeral-parlor fans
or making evening solemn by
their quietness. Feels their Mosaic eyes
upon him, though the florist roses
that only sorrow could afford
long since have bidden them Godspeed.

Oh, summer summer summertime—

Then grim street preachers shook
their tambourines and Bibles in the face
of tolerant wickedness;
then Elks parades and big splendiferous
Jack Johnson in his diamond limousine
set the ghetto burgeoning
with fantasies
of Ethiopia spreading her gorgeous wings.

SCRAPS

Louise Glück

We had codes
In our house. Like
Locks; they said
We never lock
Our door to you.
And never did.
Their bed
Stood, spotless as a tub . . .
I passed it every day
For twenty years, until
I went my way. My chore
Was marking time. Gluing
Relics into books I saw
Myself at seven learning
Distance at my mother's knee.
My favorite snapshot of my
Father shows him pushing forty
And lyrical
Above his firstborn's empty face.
The usual miracle.

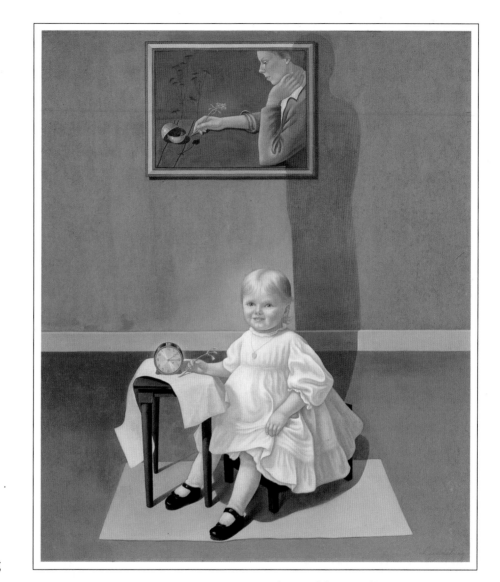

Helen Lundeberg. *Double Portrait of the Artist in Time.* 1935. Oil on fiberboard, 47³⁄₄ x 40″.
Museum purchase

THE TWELVE DANCING PRINCESSES
Sandra M. Gilbert

1

Why am I distracted all day, dreaming of the twelve princesses,
their heavy satin skirts, their swift flight across dark fields, their slow
cold sensual descent into the lake? All day the twelve princesses
circle my furniture like gulls, crying out in a strange language,
proposing mysterious patterns with their wings. Below them
indecipherable ripples wash over the carpet like white lies.

At midnight the gates of the lake swing wide: the princesses enter
the halls of water. In that blue-green ballroom they dance like
minnows, darting among stones, leaping away from circles of light.
Even as I write these words, each solitary dancer is spinning in the
palace of shadow, spinning through night so deep that the call of
the owl is not heard, and the twelve underground princes, wrapped
in sleep, row silently away across the lake.

2

I am the scholar of the dark armchair—the crimson wingchair of
1945, the overstuffed gold-tufted armchair of 1948, the downy satin
chair of 1952, and always the dark chair beneath, the chair immense
as the lap of a grandfather, the chair in which I sit reading the tale
of the twelve dancing princesses.

Winter. Wind on the fire escape. The hush of snow. Summer.
Shouts in the street. Horns, bells, processions of cars. I curl myself
into the dark armchair. I shape my body to its shape, I do not lift
my eyes.

Miles away, at the edge of the city, the twelve princesses flee
toward the airfield. Night swells the arms of the chair that holds me.
The princesses dance in the sky like helicopters. Below them the
lights of the runway burn in silence, serious as lines on a map or
instructions in a secret book: severe frontiers, all crossing forbidden.

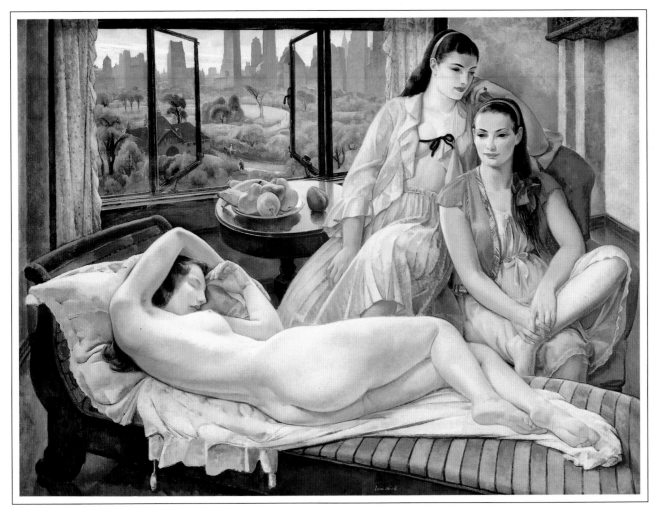

Leon Kroll. *Summer—New York*. 1931. Oil on canvas, 59 x 76". Bequest of Genevieve L. Kroll

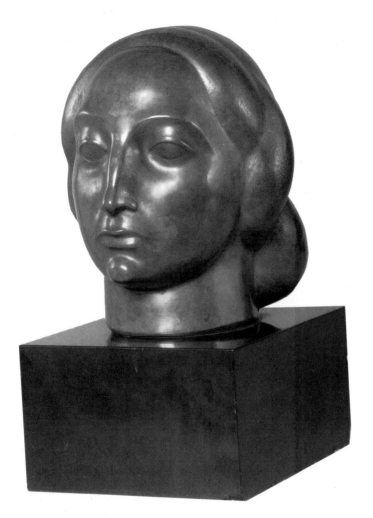

Gaston Lachaise. *Head of a Woman.* 1935. Cast bronze on marble base, 15¼ x 8½ x 10″. Gift of the Sara Roby Foundation

SUCH A LOVELY HEAD IT WAS
From They Stooped to Folly
Ellen Glasgow

After a quarter of a century, his conscience still accused him when he remembered her loneliness while the storm broke over her head. Such a lovely head it was then and even to-day; so high, so proud, so like a golden rose in its airy grace. To be sure, he had done more than the rest to protect her; but had he, in the face of his accusing conscience, done all that he could?

MY LOVE
e. e. cummings

my love
thy hair is one kingdom
 the king whereof is darkness
thy forehead is a flight of flowers

thy head is a quick forest
 filled with sleeping birds
thy breasts are swarms of white bees
 upon the bough of thy body
thy body to me is April
in whose armpits is the approach of spring

thy thighs are white horses yoked to a chariot
 of kings
they are the striking of a good minstrel
between them is always a pleasant song

my love
thy head is a casket
 of the cool jewel of thy mind
the hair of thy head is one warrior
 innocent of defeat
thy hair upon thy shoulders is an army
 with victory and with trumpets

thy legs are the trees of dreaming
whose fruit is the very eatage of forgetfulness

thy lips are satraps in scarlet
 in whose kiss is the combinings of kings
thy wrists
are holy
 which are the keepers of the keys of thy blood
thy feet upon thy ankles are flowers in vases
 of silver
in thy beauty is the dilemma of flutes

 thy eyes are the betrayal
of bells comprehended through incense

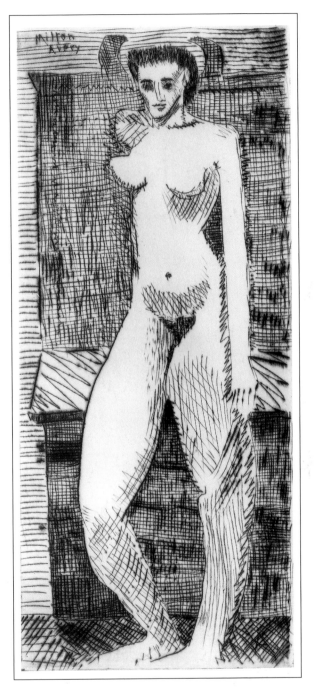

Milton Avery. *Young Girl Nude.* 1935. Drypoint on paper,
9⅞ x 4¼". Gift of Ruth and Jacob Kainen

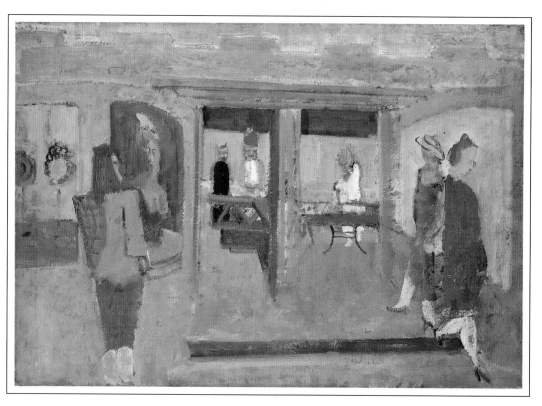

Mark Rothko. *Untitled (Women Window Shopping)*. c. 1936. Oil on canvas, 27 x 38″. Gift of the Mark Rothko Foundation, Inc.

IN FLORAL HEIGHTS

From Babbitt

Sinclair Lewis

In Floral Heights and the other prosperous sections of Zenith, especially in the "young married set," there were many women who had nothing to do. Though they had few servants, yet with gas stoves, electric ranges and dish-washers and vacuum cleaners, and tiled kitchen walls, their houses were so convenient that they had little housework, and much of their food came from bakeries and delicatessens. They had but two, one, or no children; and despite the myth that the Great War had made work respectable, their husbands objected to their "wasting time and getting a lot of crank ideas" in unpaid social work, and still more to their causing a rumor, by earning money, that they were not adequately supported. They worked perhaps two hours a day, and the rest of the time they ate chocolates, went to the motion-pictures, went window-shopping, went in gossiping twos and threes to cardparties, read magazines, thought timorously of the lovers who never appeared, and accumulated a splendid restlessness which they got rid of by nagging their husbands. The husbands nagged back.

TIRED AND UNHAPPY

Delmore Schwartz

Tired and unhappy, you think of houses
Soft-carpeted and warm in the December evening,
While snow's white pieces fall past the window,
And the orange firelight leaps.
 A young girl sings
That song of Gluck where Orpheus pleads with
 Death;
Her elders watch, nodding their happiness
To see time fresh again in her self-conscious eyes:

The servants bring the coffee, the children retire,
Elder and younger yawn and go to bed,
The coals fade and glow, rose and ashen,
It is time to shake yourself! and break this
Banal dream, and turn your head
Where the underground is charged, where the
 weight
Of the lean buildings is seen,
Where close in the subway rush, anonymous
In the audience, well-dressed or mean,
So many surround you, ringing your fate,
Caught in an anger exact as a machine!

O. Louis Guglielmi. *Relief Blues.* c. 1938. Tempera on fiberboard,
24 x 29⅞″. Transfer from Museum of Modern Art

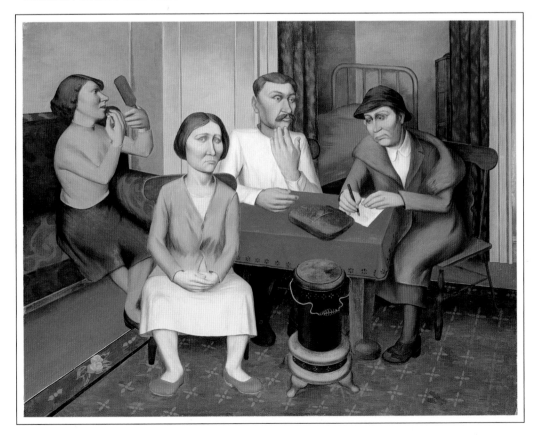

THE GARDEN
H.D. (Hilda Doolittle)

I

You are clear,
O rose, cut in rock.

I could scrape the colour
From the petals,
Like spilt dye from a rock.

If I could break you
I could break a tree.

If I could stir
I could break a tree,
I could break you.

II

O wind, rend open the heat,
Cut apart the heat,
Slit it to tatters.
Fruit cannot drop
Through this thick air;
Fruit cannot fall into heat
That presses up and blunts
The points of pears,
And rounds grapes.

Cut the heat:
Plough through it,
Turning it on either side
Of your path.

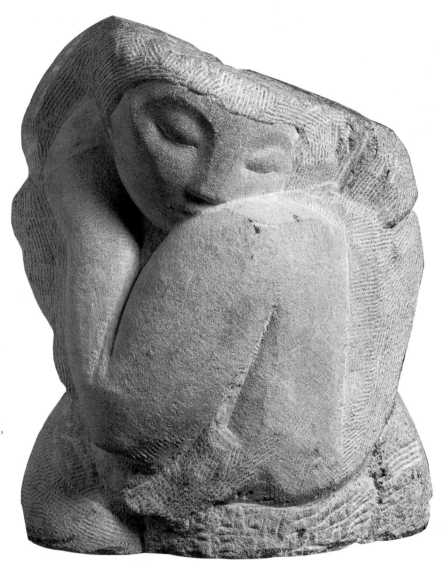

Moissaye Marans. *Woman's Head.*
n.d. Limestone, 17¼ x 13½ x 9¼".
Bequest of Moissaye Marans

TURN FROM THAT GIRL

From "I Shall Laugh Purely"
Robinson Jeffers

Turn from that girl
Your fixed blue eyes.
Boy-slender she is,
And a face as beautiful as a hawk's face.
History passes like falling rocks.

I am old as a stone,
But she is beautiful.
War is coming.
All the fine boys will go off to war.
History passes like falling rocks.

Oh, that one's to marry
Another old man;
You won't be helped
When your tall sons go away to war.
History falls on your head like rocks.

Keep a straight mind
In the evil time
In the mad-dog time
Why may not an old man run mad?
History falls like rocks in the dark,
All will be worse confounded soon.

Man Ray. *Untitled (Portrait of Ruth Ford)*.
c. 1945. Solarized gelatin silver print on
paper, 9¹⁵⁄₁₆ x 8″. Gift of Juliet Man Ray

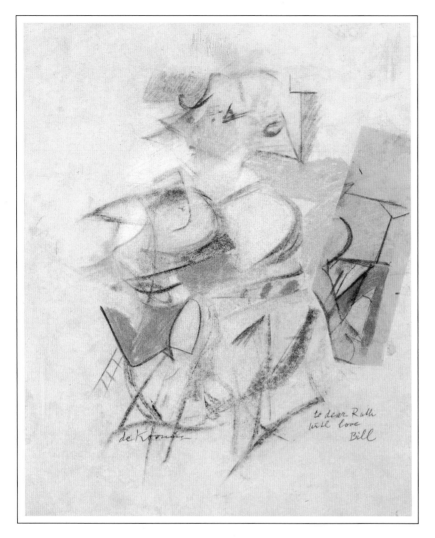

Willem de Kooning. *Woman.* c. 1952–53. Pastel on paper mounted on canvas, 23½ x 18½". Museum purchase from the Vincent Melzac Collection through the Smithsonian Institution Collections Acquisition Program

EFFORT AT SPEECH BETWEEN TWO PEOPLE
Muriel Rukeyser

:　Speak to me.　　Take my hand.　　What are you now?
I will tell you all.　　I will conceal nothing.
When I was three, a little child read a story about a rabbit
who died, in the story, and I crawled under a chair　:
a pink rabbit　:　it was my birthday, and a candle
burnt a sore spot on my finger, and I was told to be happy.

: Oh, grow to know me. I am not happy. I will be open:
 Now I am thinking of white sails against a sky like music,
 like glad horns blowing, and birds tilting, and an arm about me.
 There was one I loved, who wanted to live, sailing.

: Speak to me. Take my hand. What are you now?
 When I was nine, I was fruitily sentimental,
 fluid : and my widowed aunt played Chopin,
 and I bent my head on the painted woodwork, and wept.
 I want now to be close to you. I would
 link the minutes of my days close, somehow, to your days.

: I am not happy. I will be open.
 I have liked lamps in evening corners, and quiet poems.
 There has been fear in my life. Sometimes I speculate
 On what a tragedy his life was, really.

: Take my hand. Fist my mind in your hand. What are you now?
 When I was fourteen, I had dreams of suicide,
 and I stood at a steep window, at sunset, hoping toward death :
 if the light had not melted clouds and plains to beauty,
 if light had not transformed that day, I would have leapt.
 I am unhappy. I am lonely. Speak to me.

: I will be open. I think he never loved me:
 he loved the bright beaches, the little lips of foam
 that ride small waves, he loved the veer of gulls:
 he said with a gay mouth: I love you. Grow to know me.

: What are you now? If we could touch one another,
 if these our separate entities could come to grips,
 clenched like a Chinese puzzle . . . yesterday
 I stood in a crowded street that was live with people,
 and no one spoke a word, and the morning shone.
 Everyone silent, moving. . . . Take my hand. Speak to me.

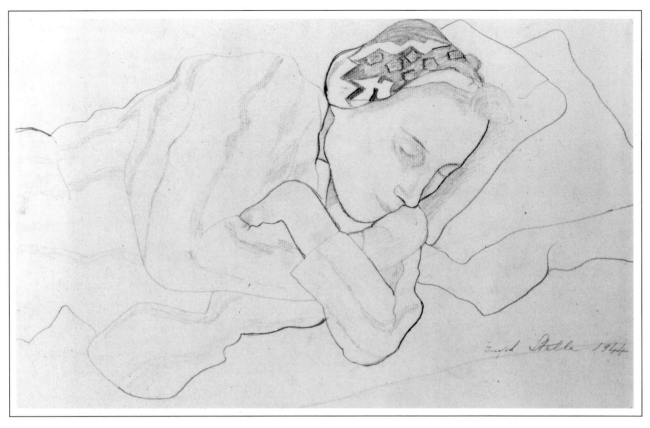

Joseph Stella. *Portrait of Clara Fasano.* 1944. Pencil and pastel on paper, 12 x 18"

THE VACUUM
Howard Nemerov

The house is so quiet now
The vacuum cleaner sulks in the corner closet,
Its bag limp as a stopped lung, its mouth
Grinning into the floor, maybe at my
Slovenly life, my dog-dead youth.

I've lived this way long enough,
But when my old woman died her soul
Went into that vacuum cleaner, and I can't bear

To see the bag swell like a belly, eating the dust
And the woolen mice, and begin to howl

Because there is old filth everywhere
She used to crawl, in the corner and under the
 stair.
I know now how life is cheap as dirt,
And still the hungry, angry heart
Hangs on and howls, biting at air.

Joseph Cornell. *Untitled (Medici Slot)*. Late 1940s. Unfinished wood construction with glass, tempera, paper reproductions, and wood balls, $23\frac{7}{8} \times 16\frac{1}{8} \times 4\frac{9}{16}$″. Gift of Mr. and Mrs. John A. Benton

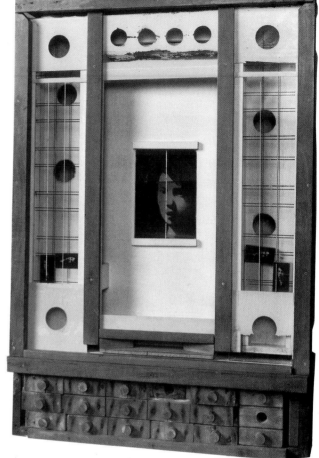

I LIVED WITH MR. PUNCH

From "Variations"
Randall Jarrell

"I lived with Mr. Punch, they said my name was Judy,
I beat him with my rolling-pin, he hit me with his cane.
I ran off with a soldier, he followed in a carriage,
And he drew a big revolver and he shot me through the brain.
But that was his duty, he only did his duty—"

Said Judy, said the Judy, said poor Judy to the string.

"O hear her, just hear her!" the string said softly.
And the string and Judy, they said no more.
Yes, string or Judy, it said no more.
But they hanged Mr. Punch with a six-inch rope,
And "Clap," said the manager; "the play is over."

A BLACK MAN TALKS OF REAPING

Arna Bontemps

I have sown beside all waters in my day.
I planted deep, within my heart the fear
that wind or fowl would take the grain away.
I planted safe against this stark, lean year.

I scattered seed enough to plant the land
in rows from Canada to Mexico
but for my reaping only what the hand
can hold at once is all that I can show.

Yet what I sowed and what the orchard yields
my brother's sons are gathering stalk and root;
small wonder then my children glean in fields
they have not sown, and feed on bitter fruit.

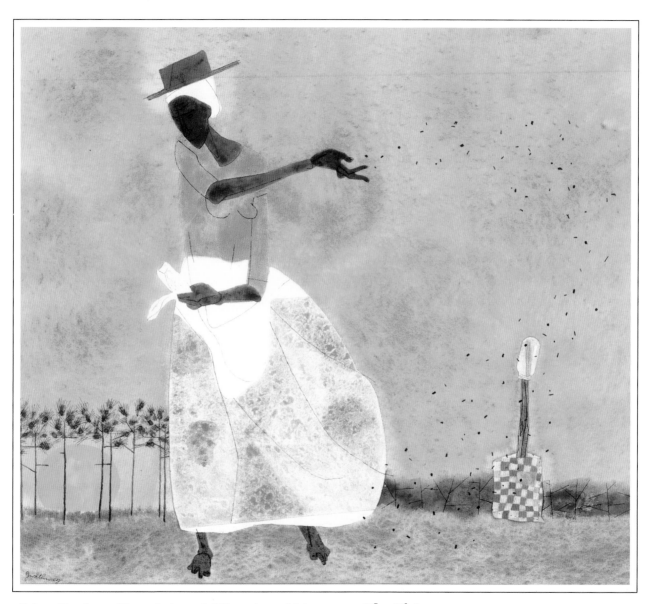

Robert Gwathmey. *Woman Sowing.* n.d. Watercolor and ink on paper, 13⅞ x 15⅜".
Gift of International Business Machines Corporation

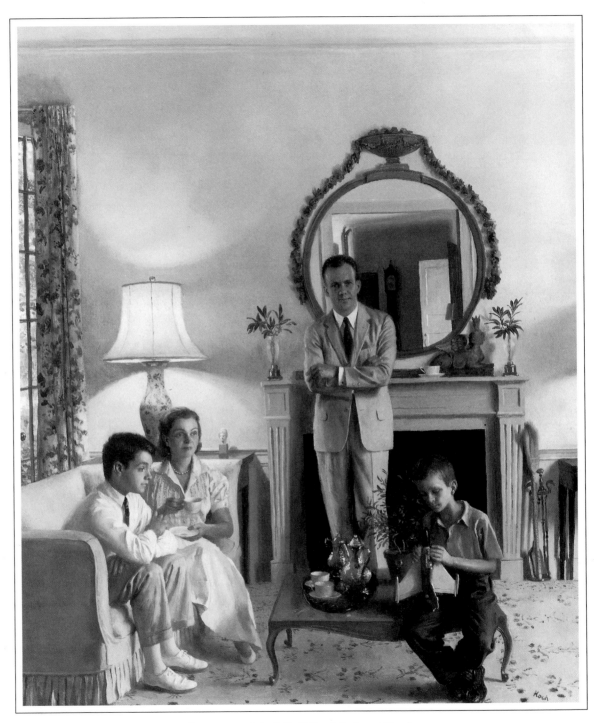

John Koch. *Family Group.* 1951. Oil on canvas, 24 x 20″. Gift of Barbara Wood

MUSIC I HEARD

Conrad Aiken

Music I heard with you was more than music,
And bread I broke with you was more than bread;
Now that I am without you, all is desolate;
All that was once so beautiful is dead.

Your hands once touched this table and this silver,
And I have seen your fingers hold this glass.
These things do not remember you, beloved,
And yet your touch upon them will not pass.

For it was in my heart you moved among them,
And blessed them with your hands and with your eyes;
And in my heart they will remember always,—
They knew you once, O beautiful and wise.

WARNING WITH LOVE

John Holmes

Always be careful. Keep yourself with care.
The sky might fall, or you might fall yourself.
The earth might open suddenly. Beware.
Even if you are not a figure on a shelf,
There are other ways to break yourself to bits.
Get sleep enough, get love and music, get
Enough earth, air, and fire to keep your wits
Against more subtly threatening dangers yet:

Stars in their courses stumbling into dark
Above you; you yourself in silence held,
Or over-sleeping into death's long sleep.
Be careful always. Mark the seasons, mark
The hours, be curious, be one impelled
To live awake as long as the pulses leap.

Philip Evergood. *Woman at the Piano.*
60 x 36⅛″. 1955. Oil on canvas,
Gift of S.C. Johnson & Son, Inc.

SO THAT NO LIGHT WILL BE LOST
Mary Ann Larkin

I am getting ready to entertain
paint my sleeping porch white
even the floor
so that no light will be lost
My Indian spread of orange and yellows,
The Tree of Life,
I lay on my bed
On the floor
my Mexican rug

black and white
with many colored fishes
From the ceiling I suspend green ferns
and coleus turning purple from the sun
like old men's noses
I bathe and perfume myself
take pen and book and wait
All the clocks are still
Only the water over the stone can be heard

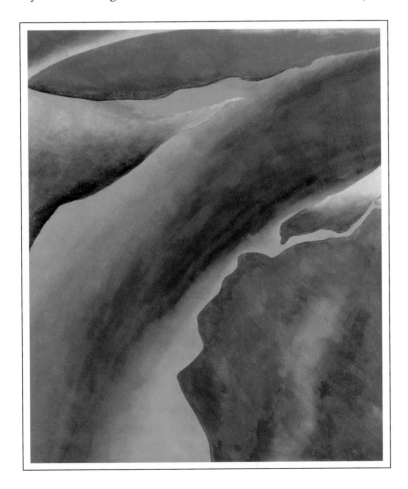

Georgia O'Keeffe. *Only One.* 1959.
Oil on canvas, 36 x 30⅛". Gift of
S.C. Johnson & Son, Inc.

THE INDIGO BUNTING
Robert Bly

I go to the door often.
Night and summer. Crickets
lift their cries.
I know you are out.
You are driving
late through the summer night.

I do not know what will happen.
I have no claim on you.
I am one star
you have as guide; others
love you, the night
so dark over the Azores.

You have been working outdoors,
gone all week. I feel you
in this lamp lit
so late. As I reach for it
I feel myself
driving through the night.

I love a firmness in you
that disdains the trivial
and regains the difficult.
You become part then
of the firmness of night,
the granite holding up walls.

There were women in Egypt who
supported with their firmness the stars
as they revolved,
hardly aware

of the passage from night
to day and back to night.

I love you where you go
through the night, not swerving,
clear as the indigo
bunting in her flight,
passing over two
thousand miles of ocean.

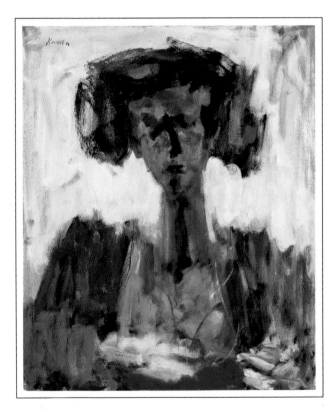

Jacob Kainen. *Woman with Dark Hair.*
1959. Oil on canvas, 44 x 36″. Gift of
Mrs. Mary Jane Fisher

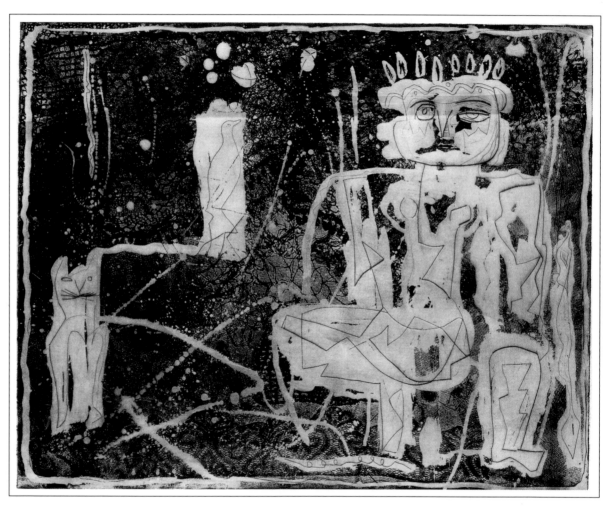

Louise Nevelson. *Figure*. 1958. Softground etching and drypoint on paper, 15¾ x 19¾". Museum purchase

THE APPLICANT
Sylvia Plath

First, are you our sort of a person?
Do you wear
A glass eye, false teeth or a crutch,
A brace or a hook,
Rubber breasts or a rubber crotch,

Stitches to show something's missing? No, no? Then
How can we give you a thing?
Stop crying.
Open your hand.
Empty? Empty. Here is a hand

To fill it and willing
To bring teacups and roll away headaches
And do whatever you tell it.
Will you marry it?
It is guaranteed

To thumb shut your eyes at the end
And dissolve of sorrow.
We make new stock from the salt.
I notice you are stark naked.
How about this suit——

Black and stiff, but not a bad fit.
Will you marry it?
It is waterproof, shatterproof, proof
Against fire and bombs through the roof.
Believe me, they'll bury you in it.

Now your head, excuse me, is empty.
I have the ticket for that.
Come here, sweetie, out of the closet.
Well, what do you think of *that*?
Naked as paper to start

But in twenty-five years she'll be silver,
In fifty, gold.
A living doll, everywhere you look.
It can sew, it can cook,
It can talk, talk, talk.

It works, there is nothing wrong with it.
You have a hole, it's a poultice.
You have an eye, it's an image.
My boy, it's your last resort.
Will you marry it, marry it, marry it.

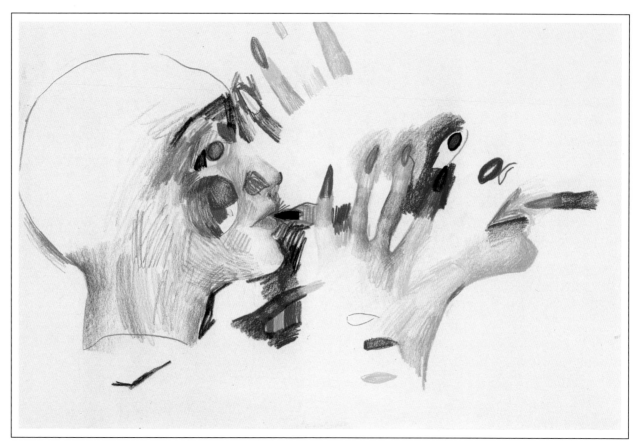

Marisol. *Untitled*. 1960. Crayon and pencil on paper,
14⁷⁄₁₆ x 21⁵⁄₁₆″. Gift of the Sara Roby Foundation

A CUT FLOWER
Karl Shapiro

I stand on slenderness all fresh and fair,
I feel root-firmness in the earth far down,
I catch in the wind and loose my scent for bees
That sack my throat for kisses and suck love.
What is the wind that brings thy body over?
Wind, I am beautiful and sick. I long
For rain that strikes and bites like cold and hurts.
Be angry, rain, for dew is kind to me
When I am cool from sleep and take my bath.

Who softens the sweet earth about my feet,
Touches my face so often and brings water?
Where does she go, taller than any sunflower
Over the grass like birds? Has she a root?
These are great animals that kneel to us,
Sent by the sun perhaps to help us grow.
I have seen death. The colors went away,
The petals grasped at nothing and curled tight.
Then the whole head fell off and left the sky.

She tended me and held me by my stalk.
Yesterday I was well, and then the gleam,
The thing sharper than frost cut me in half.
I fainted and was lifted high. I feel
Waist-deep in rain. My face is dry and drawn.
My beauty leaks into the glass like rain.
When first I opened to the sun I thought
My colors would be parched. Where are my bees?
Must I die now? Is this a part of life?

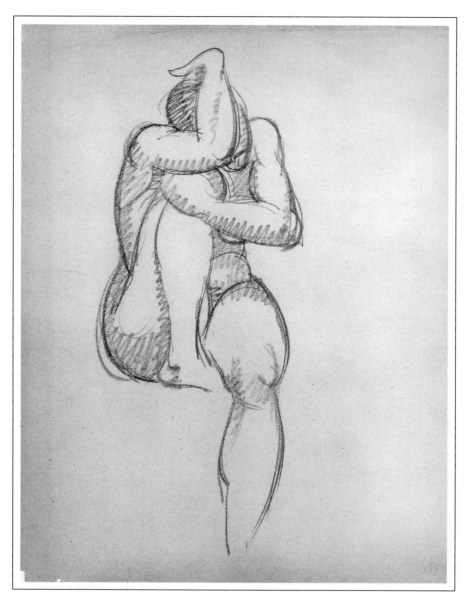

Hugo Robus. *Untitled. Seated Nude Female.* n.d. Pencil on paper,
12⅞ x 9⅞". Gift of Mr. and Mrs. Hugo E. Robus, Jr.

FOR MOTHER
Cheryl Romney-Brown

1

Mother, at forty
you gave up
your last race,
let them bind rocks
to your feet.
Slowly, you sank deeper
into the glacier lake
of your body.
Because you raced,
breaking Olympic records,
no one believed
you could drown.

2

Medicine men believed
only your womb died.
True killers never punished.
Knowing youth
can never be reborn,
you made space
for your husband
to take a younger wife.
In the darkening
of your days,
your sliver moon
disappeared.
In stark rooms,
your brain numb,
doctors unhooked
your life.

3

Yesterday, in my house
I heard chimes bell forty . . .
pianissimo,
then fortissimo.
I am alone . . .
No one waits for my end.
Blood-red rosebuds,
snow-white dogwood
spring forth in
my garden.

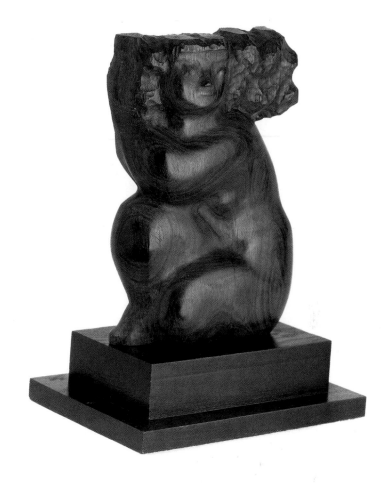

Chaim Gross. *Judith.* 1960. Wood mounted on
wood base, 13¾ x 10 x 7⅞". Gift of Chaim and
Rene Gross

HOW YOU CAN KNOW HER
Linda Gregg

Neither with nor without a lover.
Neither singing nor silent. She is either
putting on or taking off her clothes.
The water is for bathing, for washing the porch.
The house is either hers or she is a stranger
standing hidden in the trees about to be called.
She will walk easily to the door or run away.
She is either clothed in night or naked
in white silk. If she has jewelry, it was given.
If not, she doesn't mind.
She carries a love in her as a rose has its scent.

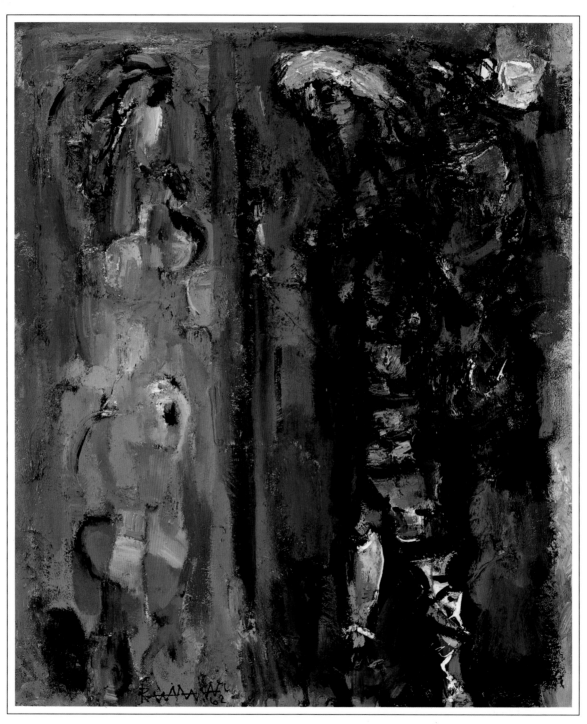

Abraham Rattner. *In the Mirror No. II.* 1962. Oil on canvas, 39 x 31½". Gift of the Estate of Abraham Rattner

THE SCARRED GIRL
James Dickey

All glass may yet be whole
She thinks, it may be put together
From the deep inner flashing of her face.
One moment the windshield held

The countryside, the green
Level fields and the animals,
And these must be restored
To what they were when her brow

Broke into them for nothing, and began
Its sparkling under the gauze.
Though the still, small war for her beauty
Is stitched out of sight and lost,

It is not this field that she thinks of.
It is that her face, buried
And held up inside the slow scars,
Knows how the bright, fractured world

Burns and pulls and weeps
To come together again.
The green meadow lying in fragments
Under the splintered sunlight,

The cattle broken in pieces
By her useless, painful intrusion
Know that her visage contains
The process and hurt of their healing,

The hidden wounds that can
Restore anything, bringing the glass

Of the world together once more,
All as it was when she struck,

All except her. The shattered field
Where they dragged the telescoped car
Off to be pounded to scrap
Waits for her to get up,

For her calm, unimagined face
To emerge from the yards of its wrapping,
Red, raw, mixed-looking but entire,
A new face, an old life,

To confront the pale glass it has dreamed
Made whole and backed with wise silver,
Held in other hands brittle with dread,
A doctor's, a lip-biting nurse's,

Who do not see what she sees
Behind her odd face in the mirror:
The pastures of earth and of heaven
Restored and undamaged, the cattle

Risen out of their jagged graves
To walk in the seamless sunlight
And a newborn countenance
Put upon everything,

Her beauty gone, but to hover
Near for the rest of her life,
And good no nearer, but plainly
In sight, and the only way.

EXIT, PURSUED BY A BEAR

Ogden Nash

Chipmunk chewing the Chippendale,
Mice on the Meissen shelf,
Pigeon stains on the Aubusson,
Spider lace on the delf.

Squirrel climbing the Sheraton,
Skunk on the Duncan Phyfe,
Silverfish in the Gobelins
And the calfbound volumes of *Life*.

Pocks on the pink Picasso,
Dust on the four Cézannes,
Kit on the keys of the Steinway,
Cat on the Louis Quinze.

Rings on the Adam mantel
From a thousand bygone thirsts,
Mold on the Henry Millers
And the Ronald Firbank firsts.

The lion and the lizard
No heavenly harmonies hear
From the high-fidelity speaker
Concealed behind the Vermeer.

Jamshid squats in a cavern
Screened by a waterfall,
Catered by Heinz and Campbell,
And awaits the fireball.

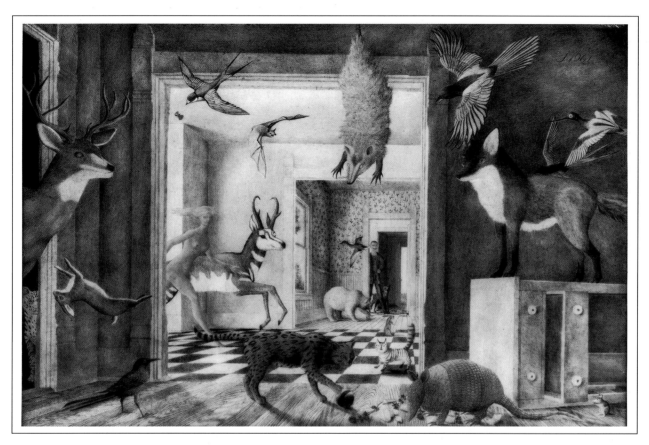

John Wilde. *Happy, Crazy, American Animals and a Man and Lady at My Place*. 1961. Oil on wood, 12 x 17⅞". Gift of S.C. Johnson & Son, Inc.

PERPETUAL MOTION
Thomas McGrath

One, one
Lives all alone,
Shape of the body's
Tree of bone.

Two, two
Can make the world do;
In youth, in youth,
But not in truth.

Three, three
And the body tree
Fades in the forest
Of company.

Three, three
Society,
Will do, will do,
But not for two

Since two, two
In love, withdraw;
Wish to be one,
To live alone,

But all must come
To the skeleton,
And one and one
Live all alone.

Andy Warhol. *Jacqueline Kennedy III*
(*11 Pop Artists, Volume III, portfolio*).
1965. Serigraph, 40 x 30".
Gift of Philip Morris Incorporated

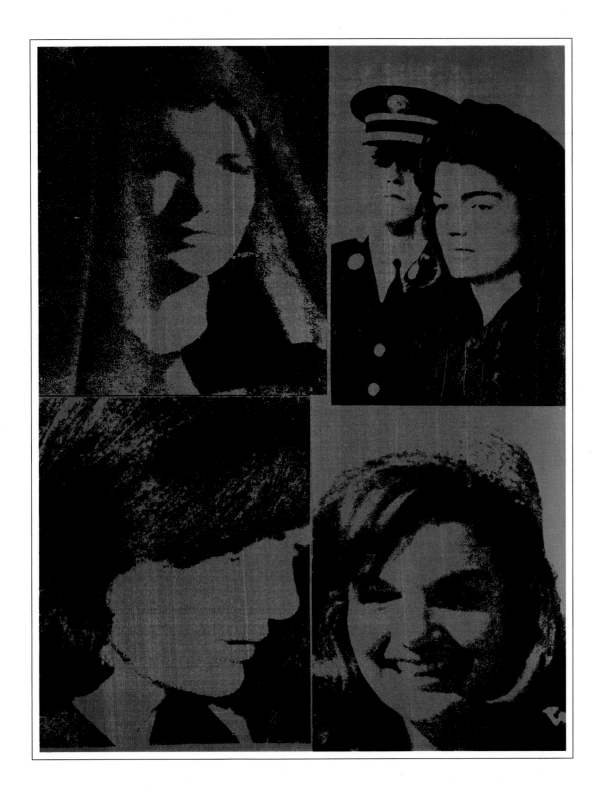

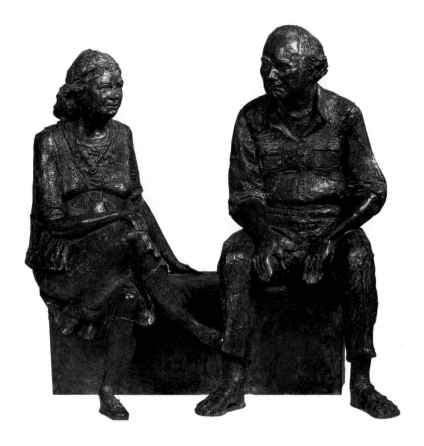

Rhoda Sherbell. *William and Marguerite Zorach.* 1964. Bronze, 18 x 18⅜ x 10⅞". Gift from the Collection of the Zorach Children

A MAN AND A WOMAN SIT NEAR EACH OTHER
Robert Bly

A man and a woman sit near each other, and they do not long
at this moment to be older, or younger, nor born
in any other nation, or time, or place.
They are content to be where they are, talking or not-talking.
Their breaths together feed someone whom we do not know.
The man sees the way his fingers move;
he sees her hands close around a book she hands to him.
They obey a third body that they share in common.
They have made a promise to love that body.
Age may come, parting may come, death will come.
A man and a woman sit near each other;
as they breathe they feed someone we do not know,
someone we know of, whom we have never seen.

OLD ROSES
Donald Hall

White roses, tiny and old, flare among thorns
by the barn door.
 For a hundred years
under the June elm, under the gaze
of seven generations,
 they lived briefly
like this, in the month of roses,
 by the fields
stout with corn, or with clover and timothy
making thick hay,
 grown over, now,
with milkweed, sumac, paintbrush.
 Old
roses survive
winter drifts, the melt in April, August
parch,
 and men and women
who sniffed roses in spring and called them pretty
as we call them now,
 walking beside the barn
on a day that perishes.

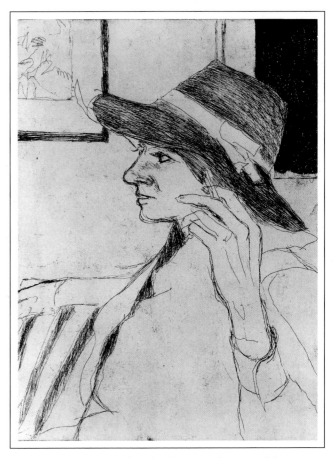

Richard Diebenkorn. #5, from portfolio 41
Etchings and Drypoints. 1965. Etching and
aquatint on paper, 9⅜ x 6¹⁵⁄₁₆″. Museum
purchase

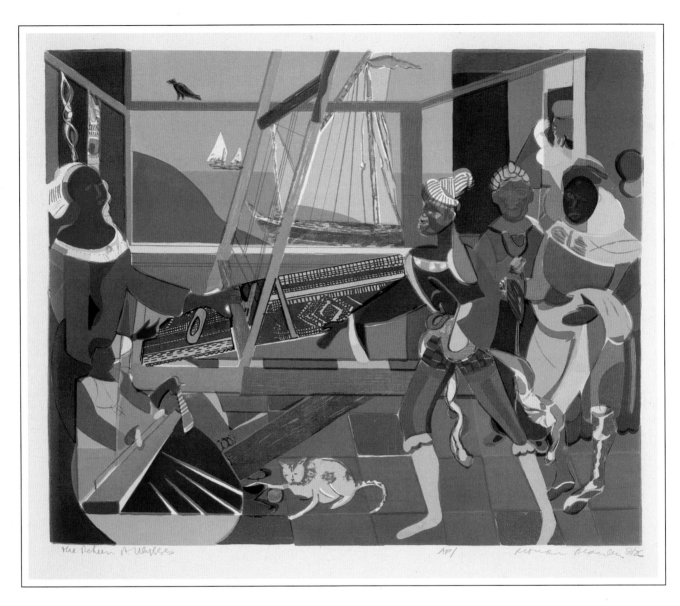

Romare Bearden. *The Return of Ulysses.* 1976.
Serigraph on paper, 18½ x 22½″. Gift of the
Brandywine Graphic Workshop

WHAT DID YOU SAY YOUR NAME WAS?
O. B. Hardison, Jr.

Lady, how was it when the gods sang?
For you were there. I know you, and you were there.
First music, then instruments,
Then radiant harmonies, plucked by intelligence from perfect frets.

For you the gods—the father of the gods himself—
Assumed old shapes:
Of earth, of flowing water, of coins sliding against your legs,
Of hills bloody with poppies where you walked,
Of mandrake crying from the battered earth.
The slavish salamander writhed at your feet,
The swan spread its wings for you,
The enormous bull that you with a thread controlled
Brought you to the source of dark rivers.

The Graces danced for you in sliding measures,
First Joy, then Grace, then Love with face averted.

When I touch you, reverent,
As one touched by the gods, I feel that music.
Tell me your name.

EDEN: OR ONE VIEW OF IT

Theodore Spencer

We come by a terrible gate;
We go out by a terrible gate;
The thunder blares and the lightning blares,
At the trembling gates there is lightning and thunder.
In between is there green? Lilacs?
Oranges in between the roses?
Are there flowers there at all, or a garden?

O lost flowers, abandoned garden,
Oranges lost between the roses,
Is the green lost between the lilacs,
Between the gates of trembling thunder?
Where thunder blares and lightning blares
As we enter the terrible gate;
And go out by the terrible gate.

Robert Rauschenberg. *Test Stone I,*
from series *Booster and Seven Studies.*
1967. Lithograph on paper, 20$\frac{1}{16}$ x
14$\frac{13}{16}$". Museum purchase

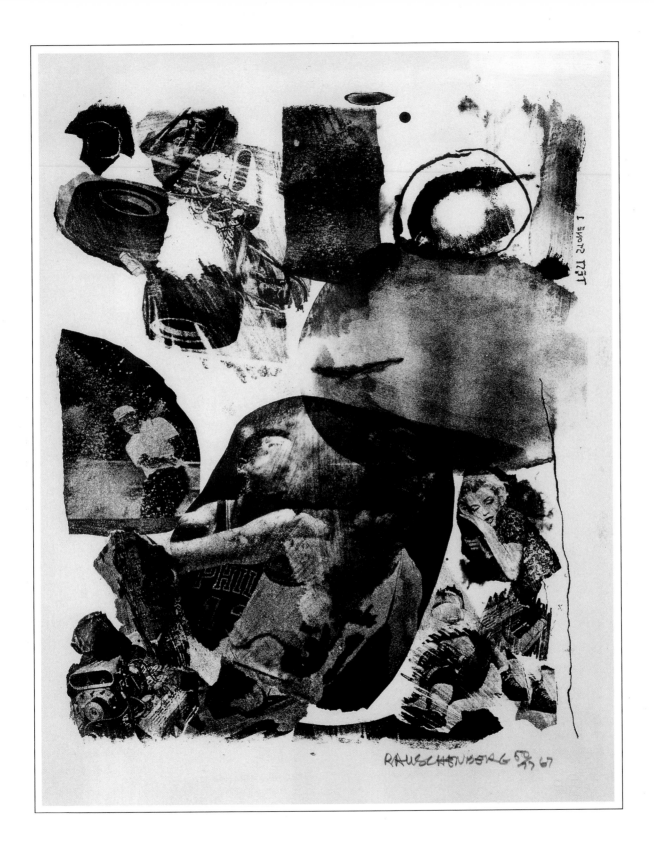

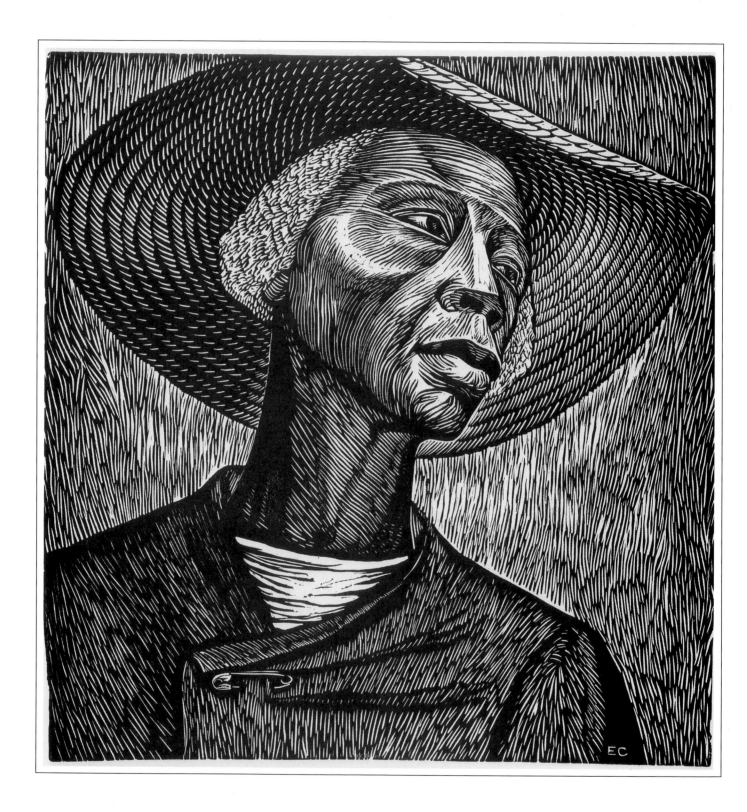

JESSIE MITCHELL'S MOTHER

Gwendolyn Brooks

Into her mother's bedroom to wash the ballooning body.
"My mother is jelly-hearted and she has a brain of jelly:
Sweet, quiver-soft, irrelevant. Not essential.
Only a habit would cry if she should die.
A pleasant sort of fool without the least iron. . . .
Are you better, mother, do you think it will come today?"
The stretched yellow rag that was Jessie Mitchell's mother
Reviewed her. Young, and so thin, and so straight.
So straight! as if nothing could ever bend her.
But poor men would bend her, and doing things with poor men,
Being much in bed, and babies would bend her over,
And the rest of things in life that were for poor women,
Coming to them grinning and pretty with intent to bend and to kill.
Comparisons shattered her heart, ate at her bulwarks:
The shabby and the bright: she, almost hating her daughter,
Crept into an old sly refuge: "Jessie's black
And her way will be black, and jerkier even than mine.
Mine, in fact, because I was lovely, had flowers
Tucked in the jerks, flowers were here and there. . . ."
She revived for the moment settled and dried-up triumphs,
Forced perfume into old petals, pulled up the droop,
Refueled
Triumphant long-exhaled breaths.
Her exquisite yellow youth . . .

Elizabeth Catlett. *Sharecropper.* 1970. Linoleum
cut on paper, 17¹³⁄₁₆ x 16¹⁵⁄₁₆″. Museum purchase

HERSELF
John Holmes

Herself listening to herself, having no name,
She walked in an airy April sun, clothes close on her
And thin and of some printed green;
A girl came nearer and nearer, came
Carrying white and yellow flowers.

Girls are smooth with sleep in the morning
And, before they dress, up out of naked bed,
Stand open to all airs,
Next to the world's body as the world's to theirs.
In the evening and at midnight, light
Curves round a girl, reaches to brush her cheek,
Her lips, loose hair, or breast or knee,
Outlining her with shining that cannot speak.

Ann at midnight and three midnights heard a voice
Saying, When you come back you will not find me here.
Or Hulda. Not Ruth, perhaps Elizabeth,
Who read next year's news in a letter, all the accidents
Postmarked, and lost it. No one believed her.

It was a dead man, if you know what it is to be dead.
Eleanor, he said, or Janet Janet Janet do you dream me?

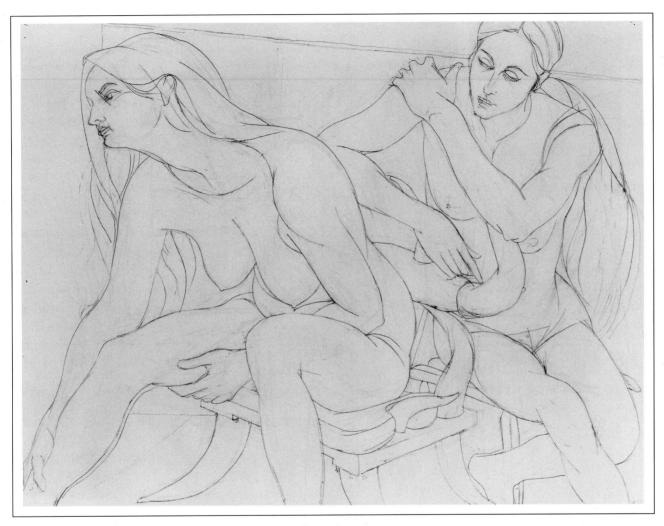

Fritz Bultman. *Tacke and Lynn.* 1970. Pencil on paper, 23¹/₁₆ x 29¹/₁₆″.
Gift of Mr. and Mrs. David K. Anderson, Martha Jackson Memorial
Collection

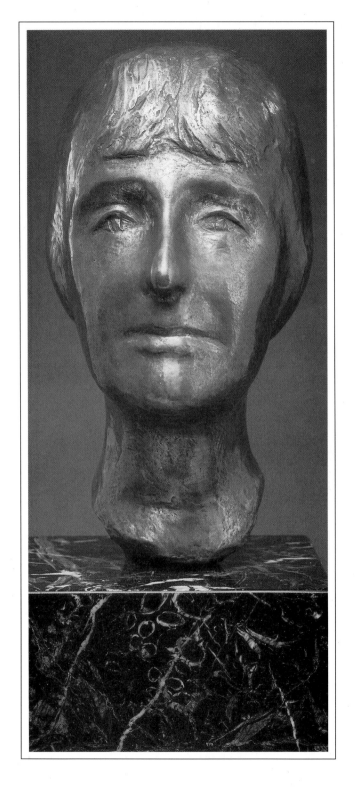

Philip Pavia. *Portrait Head of Martha Jackson.*
1971. Cast bronze, 11⅞ x 8¼ x 6¼". Gift of Mr.
and Mrs. David K. Anderson, Martha Jackson
Memorial Collection

LET NO CHARITABLE HOPE
Elinor Wylie

Now let no charitable hope
Confuse my mind with images
Of eagle and of antelope:
I am in nature none of these.

I was, being human, born alone;
I am, being woman, hard beset;
I live by squeezing from a stone
The little nourishment I get.

In masks outrageous and austere
The years go by in single file;
But none has merited my fear,
And none has quite escaped my smile.

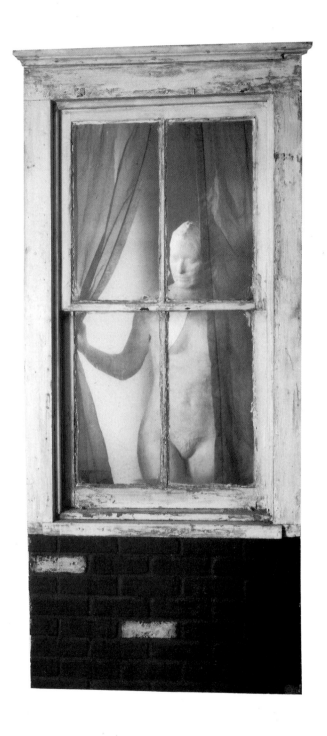

George Segal. *The Curtain*. 1974.
Mixed media: plaster, glass,
and painted wood; 84½ x 39¼ x
35½". Museum purchase

IF I STAND IN MY WINDOW
Lucille Clifton

If I stand in my window
naked in my own house
and press my breasts
against my windowpane
like black birds pushing against glass
because I am somebody
in a New Thing

and if the man come to stop me
in my own house
naked in my own window
saying I have offended him
I have offended his

Gods

let him watch my black body
push against my own glass
let him discover self
let him run naked through the streets
crying
praying in tongues

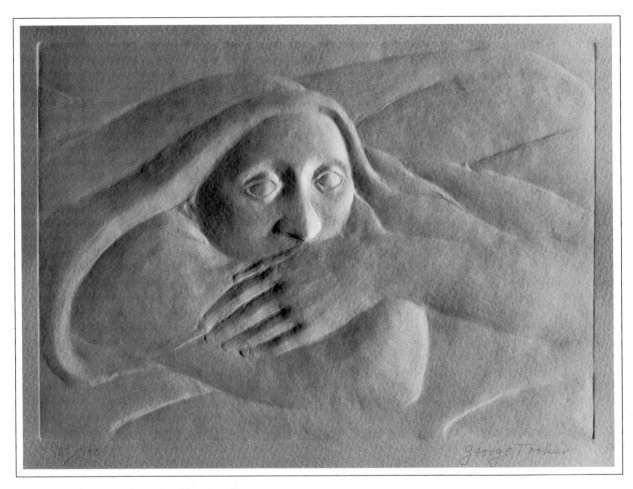

George Tooker. *Untitled.* 1976. Inkless intaglio
on paper, 6^{15}/$_{16}$ x 9^{7}/$_{8}$″. Museum purchase

WINTER INTERLUDE
From The Lover in Winter
Charles Sullivan

NOVEMBER

Overnight
my hair turns
white, my skin
wrinkles like a field
just ploughed
for winter wheat,
but I go underground—
learning how
to seem to live
the river life alone
while I pursue
two women, wife
and lover,
in this dream.

DECEMBER

In this dream
I run my fingers
through your hair,
smoothing it,
shaping it closer
to your skull,
tenderly, carefully,
as though I were one
of the sculptors, as though
I had not arrived too late
to help create
your beauty.

JANUARY

Your beauty lies
skin deep
when you're awake,
but when you sleep
I see the honesty
of bone structure
as the light—
even the least loving
light from rooms away—
gathers to reflect
on fundamentals.

FEBRUARY

On fundamentals
we could not agree,
although we often said
the same things differently,
like energy and matter—
when I tried to be a tree
you were the east wind,
battering its branches,
worrying its roots;
and now I see the waves
that washed away your beaches
came from me, I was a storm,
I was a flood, I was a spring
tide overwhelming
all that you had left
of winter.

MARCH

Of winter
I will speak
no more, of spring
say everything:
the wind is shifting
to the west, lifting
the impatient leaves, ready
for the rain to wash
the last icy traces
of my grief away,
and in my bed a woman
smooth and bright
as blossoms in the garden
overnight.

SILVERPOINT
Louise Glück

My sister, by the chiming kinks
Of the Atlantic Ocean, takes in light.
Beyond her, wreathed in algae, links on links
Of breakers meet and disconnect, foam through bracelets
Of seabirds. The wind sinks. She does not feel the change
At once. It will take time. My sister,
Stirring briefly to arrange
Her towel, browns like a chicken, under fire.

Rodger P. Kingston. *Lifeguard Stand.* 1980. Cibachrome print on paper, 13¹⁵⁄₁₆ x 10¹⁵⁄₁₆″. Gift of Dr. Robert L. Drapkin

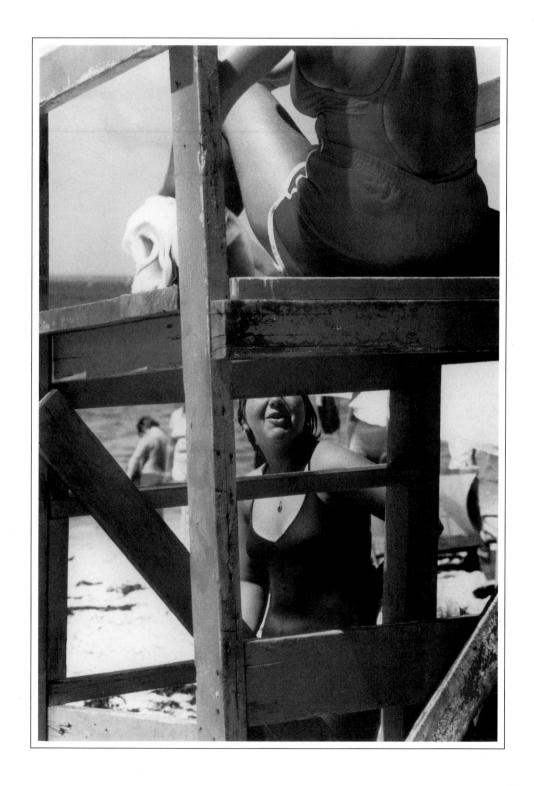

I AM ROSE

Gertrude Stein

I am Rose my eyes are blue
I am Rose and who are you
I am Rose and when I sing
I am Rose like anything

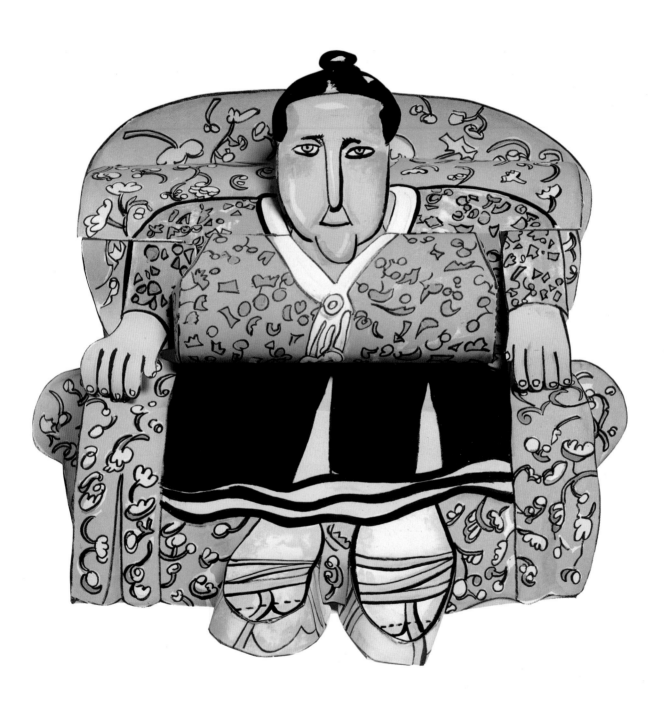

Red Grooms. *Gertrude.* 1975. Color lithograph and collage on paper, 18³/₄ x 19 x 9⁷/₈". Museum purchase with the aid of funds from Mr. and Mrs. Jacob Kainen and the National Endowment for the Arts

THEN CAME DANCES

From "Lost on September Trail, 1967"
Alberto Ríos

There was a roof over our heads
and that was at least something.
Then came dances.
The energy for them came from
childhood, or before, from the time
when only warmth was important.
We had come to the New World
and become part of it.
If the roof would shelter us,
we would keep it in repair.
Roof then could be roof,
solid, visible, recognizable,
and we could be whatever it was
that we were at this moment.
Having lost our previous names
somewhere in the rocks as we ran,
we could not yet describe ourselves.
For two days the rain had been
steady, and we left the trail
because one of us remembered
this place. Once when I was young
I had yielded to the temptation
of getting drunk, and parts of it
felt like this, wet and hot,
timeless, in the care of someone
else. After the dances we sat
like cubs, and cried for that
which in another world might be
milk, but none came.

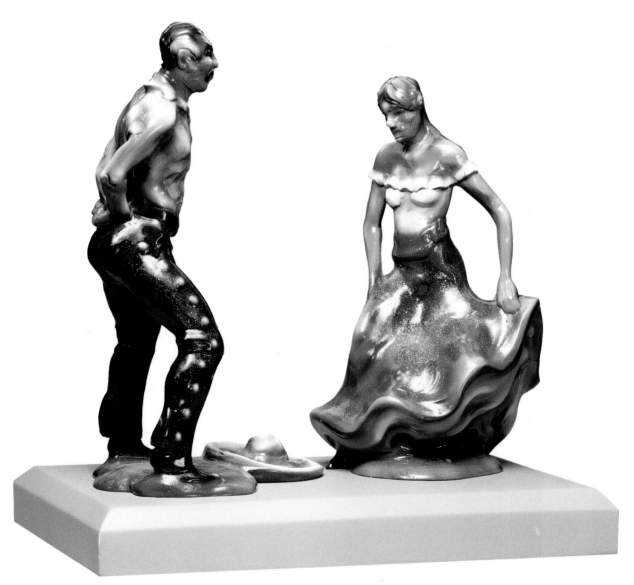

Luis Jimenez. *Model for "Fiesta."* 1986. Cast fiberglass, 19¾ x 20¼ x 13″. Transfer from General Services Administration, Public Buildings Service

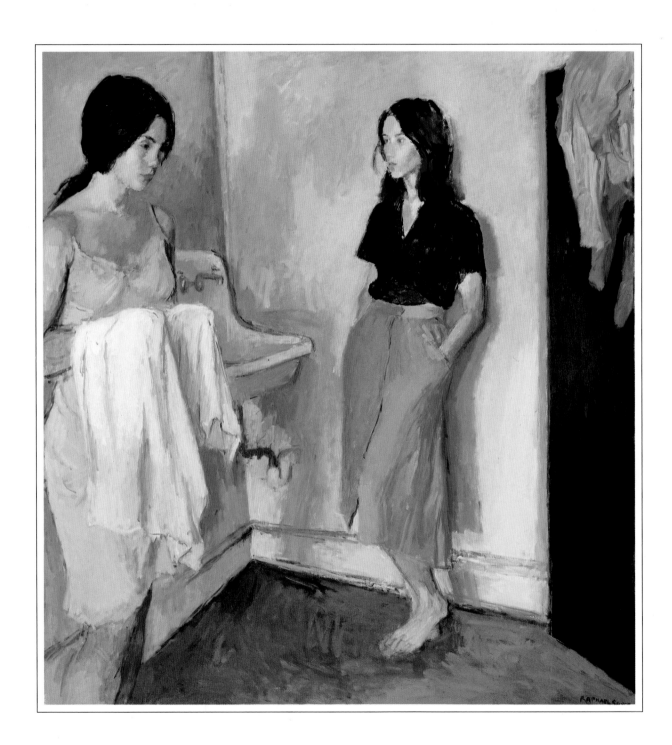

A BIRTHDAY PRESENT

Sylvia Plath

What is this, behind this veil, is it ugly, is it beautiful?
It is shimmering, has it breasts, has it edges?

I am sure it is unique, I am sure it is just what I want.
When I am quiet at my cooking I feel it looking, I feel it thinking

"Is this the one I am to appear for,
Is this the elect one, the one with black eye-pits and a scar?

Measuring the flour, cutting off the surplus,
Adhering to rules, to rules, to rules.

Is this the one for the annunciation?
My god, what a laugh!"

But it shimmers, it does not stop, and I think it wants me.
I would not mind if it was bones, or a pearl button.

I do not want much of a present, anyway, this year.
After all I am alive only by accident.

I would have killed myself gladly that time any possible way.
Now there are these veils, shimmering like curtains,

The diaphanous satins of a January window
White as babies' bedding and glittering with dead breath.
 O ivory!

It must be a tusk there, a ghost-column.
Can you not see I do not mind what it is.

Can you not give it to me?
Do not be ashamed—I do not mind if it is small.

Raphael Soyer. *Annunciation.* 1980.
Oil on linen, 56 x 50⅛". Gift of
the Sara Roby Foundation

Do not be mean, I am ready for enormity.
Let us sit down to it, one on either side, admiring the gleam,

The glaze, the mirrory variety of it.
Let us eat our last supper at it, like a hospital plate.

I know why you will not give it to me,
You are terrified

The world will go up in a shriek, and your head with it,
Bossed, brazen, an antique shield,

A marvel to your great-grandchildren.
Do not be afraid, it is not so.

I will only take it and go aside quietly.
You will not even hear me opening it, no paper crackle,

No falling ribbons, no scream at the end.
I do not think you credit me with this discretion.

If you only knew how the veils were killing my days.
To you they are only transparencies, clear air.

But my god, the clouds are like cotton.
Armies of them. They are carbon monoxide.

Sweetly, sweetly I breathe in,
Filling my veins with invisibles, with the million

Probable motes that tick the years off my life.
You are silver-suited for the occasion. O adding machine———

Is it impossible for you to let something go and have it go whole?
Must you stamp each piece in purple,

Must you kill what you can?
There is this one thing I want today, and only you can give it to me.

It stands at my window, big as the sky.
It breathes from my sheets, the cold dead centre

Where spilt lives congeal and stiffen to history.
Let it not come by the mail, finger by finger.

Let it not come by word of mouth, I should be sixty
By the time the whole of it was delivered, and too numb to use it.

Only let down the veil, the veil, the veil.
If it were death

I would admire the deep gravity of it, its timeless eyes.
I would know you were serious.

There would be a nobility then, there would be a birthday.
And the knife not carve, but enter

Pure and clean as the cry of a baby,
And the universe slide from my side.

YOU SEE PEOPLE LIKE YOU NEVER SAW THEM BEFORE
From If Beale Street Could Talk
James Baldwin

Being in trouble can have a funny effect on the mind. I don't know if I can explain this. You go through some days and you seem to be hearing people and you seem to be talking to them and you seem to be doing your work, or, at least, your work gets done; but you haven't seen or heard a soul and if someone asked you what you have done that day you'd have to think awhile before you could answer. But, at the same time, and even on the self-same day—and this is what is hard to explain—you see people like you never saw them before. They shine as bright as a razor. Maybe it's because you see people differently than you saw them before your trouble started. Maybe you wonder about them more, but in a different way, and this makes them very strange to you. Maybe you get scared and numb, because you don't know if you can depend on people for anything, anymore.

Jacob Lawrence. *"In a free government, the security of civil rights must be the same as that for religious rights. It consists in the one case in the multiplicity of interests, and in the other, in the multiplicity of sects."* from *Great Ideas Series.* 1976. Opaque watercolor and pencil on paper, 30 x 22⅛". Gift of Container Corporation of America

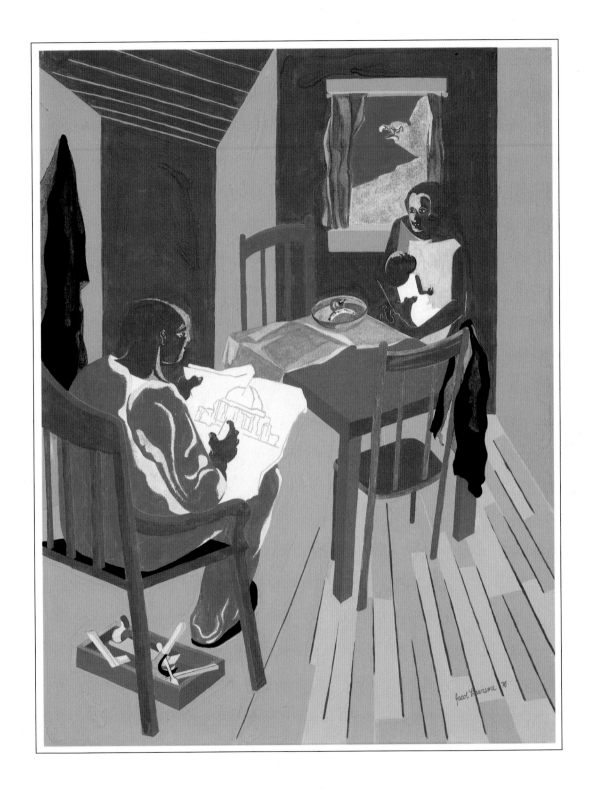

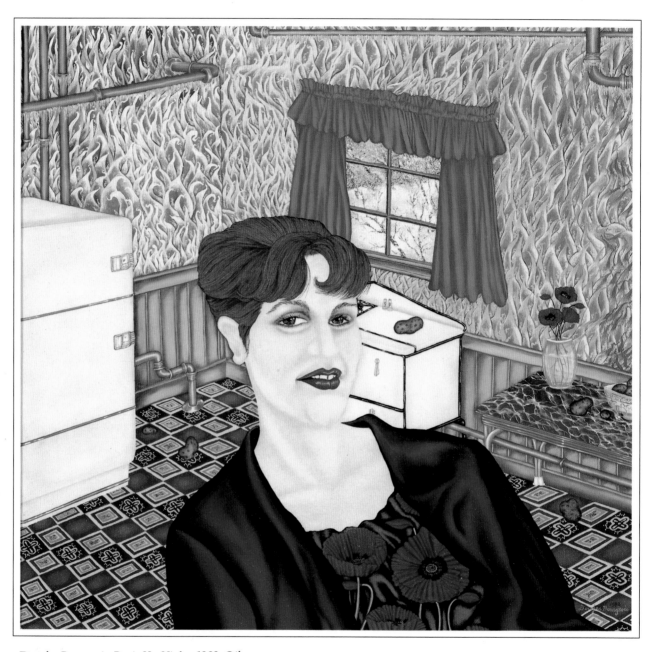

Douglas Bourgeois. *Poet in Her Kitchen.* 1982. Oil
on linen, 14 x 14″. Museum purchase through
funds provided by the Awards in the Visual
Arts Program

IT IS A SPRING AFTERNOON

Anne Sexton

Everything here is yellow and green.
Listen to its throat, its earthskin,
the bone dry voices of the peepers
as they throb like advertisements.
The small animals of the woods
are carrying their deathmasks
into a narrow winter cave.
The scarecrow has plucked out
his two eyes like diamonds
and walked into the village.
The general and the postman
have taken off their packs.
This has all happened before
but nothing here is obsolete.
Everything here is possible.

Because of this
perhaps a young girl has laid down
her winter clothes and has casually
placed herself upon a tree limb
that hangs over a pool in the river.
She has been poured out onto the limb,
low above the houses of the fishes
as they swim in and out of her reflection
and up and down the stairs of her legs.
Her body carries clouds all the way home.
She is overlooking her watery face
in the river where blind men
come to bathe at midday.

Because of this
the ground, that winter nightmare,
has cured its sores and burst
with green birds and vitamins.
Because of this
the trees turn in their trenches
and hold up little rain cups
by their slender fingers.
Because of this
a woman stands by her stove
singing and cooking flowers.
Everything here is yellow and green.

Surely spring will allow
a girl without a stitch on
to turn softly in her sunlight
and not be afraid of her bed.
She has already counted seven
blossoms in her green green mirror.
Two rivers combine beneath her.
The face of the child wrinkles
in the water and is gone forever.
The woman is all that can be seen
in her animal loveliness.
Her cherished and obstinate skin
lies deeply under the watery tree.
Everything is altogether possible
and the blind men can also see.

Conrad Aiken (1889–1973). Born in Georgia, lived there and elsewhere. Prolific poet, critic, novelist. Consultant in Poetry at the Library of Congress, 1950–52. Won the Pulitzer Prize in 1930, the National Book Award in 1954, other honors.

Sherwood Anderson (1876–1941). Born in Ohio, lived in various places. Influential writer who once described himself as "the minor author of a minor masterpiece," referring to his book of small-town tales, *Winesburg, Ohio* (1919).

Milton Avery (1885–1965). Born in New York State, moved to New York City in 1925. Artist who became one of America's greatest colorists; also demonstrated his mastery of figurative line and shape in drypoints and monotypes.

James Baldwin (1924–1987). Born and lived mostly in New York City. Impassioned writer who brought worldwide attention to African-American people with *Go Tell It on the Mountain* (1953), *The Fire Next Time* (1963), and other books.

Alice Pike Barney (1857?–1931). Born in Cincinnati, lived in various places, including Paris, Washington, D.C., and Hollywood. Artist, playwright, patron of the arts. Her Studio House in Washington, D.C., the scene of many cultural salons, 1903–25, is now owned by the NMAA.

Romare Bearden (1911–1988). Born in North Carolina; studied in the U.S. and in Paris; lived mostly in New York City. Dynamic artist who created archetypal figures of African Americans and others by combining different kinds of images, using oil paint or collage materials.

Thomas Beer (1889–1940). Born in Iowa, lived in various places. Author best known for *The Mauve Decade* (1926) and *Mrs. Egg and Other Barbarians* (1933).

George Wesley Bellows (1882–1925). Born in Columbus, Ohio; lived mostly in New York City. Realist painter who won many prizes for his lively, authentic scenes of contemporary life in the United States.

Frank Weston Benson (1862–1951). Born in Massachusetts, lived in Boston. Impressionist artist who became famous early for his idealized pictures of young women; later painted murals, still lifes, and sporting scenes.

Robert Bly (Born 1926). Born and lives in Minnesota, travels extensively. Outspoken poet and activist, winner of the National Book Award in 1968, more recently recognized as a leader of the men's liberation movement with his prose classic, *Iron John* (1990).

Arna Bontemps (1902–1973). Born in Tennessee, lived in various places. Man of letters who wrote about African-American history and related topics; his poetry, including *Personals* (1963), deserves more appreciation.

Henry Breintell Bounetheau (1797–1877). Born and lived in Charleston, South Carolina. Artist, teacher whose crayon portraits and miniature paintings were locally popular, but whose main occupation was accounting.

Douglas Bourgeois (Born 1951). Born and lives in Louisiana. Figurative artist, one of the new "visionary imagists" of the American South, whose preferred medium is oil on wood.

Gwendolyn Brooks (Born 1917). Born in Kansas, lives in Chicago. Strong, appealing writer who has received the Pulitzer Prize, 1950, and many other honors; Consultant in Poetry at the Library of Congress, 1985–86.

Romaine Brooks (née Goddard) (1874–1970). Born in Rome, spent most of the first part of her life in Europe, lived in New York City, 1940–67. After early acclaim, this controversial artist was neglected for decades, but

her work (including many paintings and drawings given to NMAA) has recently attracted more attention.

William Cullen Bryant (1794–1878). Born in Massachusetts, lived there and in New York. Poet, newspaper editor, and lawyer, a close friend of Thomas Cole, the painter; Asher Durand's *Kindred Spirits* (1849) shows the two together in the Adirondack Mountains, near their beloved Hudson River.

Fritz Bultman (1919–1985). Born in New Orleans, lived mostly in New York City. Abstract Expressionist painter, later a sculptor, who won several awards; one of the "Irascibles."

Alexander Calder (1898–1976). Born in Philadelphia, later lived in Connecticut and France. Versatile, prolific artist whose works range from delicate jewelry and small animal sculptures to huge abstract mobiles (hanging objects) and stabiles (standing objects).

Mary Cassatt (1844–1926). Born and lived in Pennsylvania, settled in Paris. Outstanding painter, pastelist, and printmaker, whose pictures of women and children are known and greatly admired throughout the world.

Elizabeth Catlett (Born 1919). Born in Washington, D.C., lives in Mexico. Prizewinning artist, teacher whose prints and sculptures, such as *Homage to My Young Black Sisters* (1968) and later works, express her concern about social problems.

George Catlin (1796–1872). Born in Pennsylvania, lived in Philadelphia, spent much of his time in the West. Painted hundreds of distinctive portraits and action pictures of Native Americans; said: "I was luckily born in time to see these people in their native dignity, and beauty, and independence." NMAA has a large collection of his work.

William Merritt Chase (1849–1916). Born in Indiana, lived mostly in New York City. Influential artist, teacher, who was in turn influenced by various European styles as he painted inviting scenes of family and friends at home, in the studio, or outdoors.

Lucille Clifton (Born 1936). Born in New York, lives in Washington, D.C. Poet, professor whose books include *Good Times* (1969) and *Next: New Poems* (1987). Also writes for children; won an Emmy Award, 1974, as coauthor of *Free to Be You and Me*.

John Singleton Copley (1738–1815). Born in Boston, moved to London in 1774. The most celebrated American artist of the 18th century, he achieved great success first as a portraitist in Massachusetts, later as a history painter in England.

Joseph Cornell (1903–1972). Born in New York State, lived in New York City starting in 1929. Object- and assemblage-maker who said of his work: "Shadow boxes become poetic theaters or settings wherein are metamorphosed the elements of a childhood pastime."

Kenyon Cox (1856–1919). Born in Ohio, studied in Paris, lived mostly in New York City. Painter who wrote extensively about art. His sensuous female nudes were beautifully rendered but were somewhat shocking to the public of his day; later he found wider acceptance as a creator of allegorical murals.

Louise Howland King Cox (1865–1945). Born in San Francisco, lived in New York City. Painter who specialized in children's portraits, won several prizes.

e. e. cummings (1894–1962). Born in Massachusetts, lived in New York City and elsewhere. Poet whose individualistic, sometimes idiosyncratic verse forms have not completely disguised his depth of feeling and his lyric gifts; also a painter of some interest.

Charles Courtney Curran (1861–1942). Born in Kentucky, studied in Paris, lived mostly in New York City. Fashionable painter who won many prizes and sold many paintings to museums and collectors.

Arthur Bowen Davies (1862–1928). Born in New York State, lived mostly in New York City. Painter, muralist, and printmaker who helped to organize the Armory Show of 1913 and other trend-setting exhibitions, although he was not himself a modernist.

Willem de Kooning (Born 1904). Born in Holland, moved to the United States in 1924. Abstract Expressionist painter, known for his disturbing pictures of women, who became one of the dominant American artists of the 1950s.

Thomas Dewing (1851–1938). Born in Boston, studied in Paris, settled in New York City. A sensitive figure painter and accomplished draftsman who specialized in ethereal pictures of women; he virtually ceased painting after 1920.

James Dickey (Born 1923). Born in Georgia, lives in South Carolina. Prizewinning poet and novelist, Consultant in Poetry at the Library of Congress, 1966–68, Professor of English and writer-in-residence since 1969, University of South Carolina.

Emily Dickinson (1830–1886). Born and lived in Massachusetts. Reclusive poet whose work has become known and respected throughout the world in recent years; most of it was published posthumously.

Richard Diebenkorn (Born 1922). Born in Oregon, lives in California. Influential artist who won early fame for his abstract paintings but also inspired a return to figurative work through pictures he produced starting in the 1950s.

Hilda Doolittle, *see* H.D.

Theodore Dreiser (1871–1945). Born in Indiana, later lived in California. Writer who attracted attention with early novels, such as *Sister Carrie* (1900), received much praise for *An American Tragedy* (1925) and other innovative books.

Paul Laurence Dunbar (1872–1906). Born and lived in Ohio. Wrote many books of fiction and poetry about the African-American experience, starting with *Oak and Ivy* (1893) and *Majors and Minors* (1895).

Asher Brown Durand (1796–1886). Born in New Jersey, lived in New York City. Best known as a landscape artist of the Hudson River School; his *Kindred Spirits* (1849) celebrates the friendship of William Cullen Bryant and Thomas Cole, thus the relationship of American poetry and painting.

Thomas Eakins (1844–1916). Born in Philadelphia, lived mostly in that area. Painter, photographer, sculptor, and controversial teacher; he achieved greatness in psychologically astute portraits and in luminous outdoor scenes.

Max Eastman (1883–1969). Born in New York State, lived mostly in New York City. Author, journalist, reformer who supported women's suffrage and other causes; poetry books include *Kinds of Love* (1931).

Louis Michel Eilshemius (1864–1941). Born in New Jersey, studied in Europe, 1873–81, settled in New York City. Idiosyncratic painter who called himself a "Transcendental Eagle of the Arts" but whose increasingly subjective pictures received little attention during his lifetime.

T. S. Eliot (1888–1965). Born in Missouri, later moved to England. Poet, playwright, and critic who had great influence on his generation, especially with *The Waste Land* (1922). Became a British citizen in 1927, won the Nobel Prize in 1948.

Ralph Waldo Emerson (1803–1882). Born and lived in Massachusetts. Inspirational poet, public speaker, philosopher who believed in the unlimited potential of the individual; his books, such as *Nature* (1836) and *Poems* (1847), were very popular.

Philip Evergood (né Blashki) (1901–1975). Born in New York City, lived in Europe 1909–31. Painter, teacher, magazine illustrator whose longtime interest in fantasy was interrupted by a period of social realism during the 1930s.

F. Scott Fitzgerald (1896–1940). Born in Minnesota, lived in New York, California, France, and elsewhere. An immensely talented author who sometimes wasted his gifts, died young, was almost forgotten, but is now

recognized as one of America's finest novelists and short story writers.

Benjamin Franklin (1706–1790). Born in Boston, lived mostly in Philadelphia and abroad. Scientist, philosopher, and statesman, a visionary with a practical bent, who could find something quotable to say on almost any topic.

Robert Frost (1874–1963). Born in San Francisco, lived mostly in New England, traveled frequently. One of America's most popular and widely read poets, a dedicated teacher as well; awarded the Pulitzer Prize in 1924, 1931, 1937, and 1943, among other honors; Consultant in Poetry at the Library of Congress, 1958.

Sarah Margaret Fuller (1810–1850). Born in Massachusetts, later lived in New York City and in Italy. Feminist author, critic, who wrote about various subjects, including *Woman in the Nineteenth Century* (1846).

Sandra M. Gilbert (Born 1936). Born in New Jersey, lives in California. Feminist author, university professor, whose poetry books include *Emily's Bread* (1984) and *Blood Pressure* (1988).

William J. Glackens (1870–1938). Born in Philadelphia, settled in New York City. Newspaper and magazine illustrator, became a realist painter and printmaker, one of "The Eight" whose exhibition in 1908 caused much debate. His colorful scenes of American life are found in many museums.

Ellen Glasgow (1873–1945). Born and lived mostly in Virginia. Wrote twenty novels about Southern life, such as *Barren Ground* (1925) and *They Stooped to Folly* (1929); won the Pulitzer Prize for fiction in 1942.

Louise Glück (Born 1943). Born in New York City, lives in Massachusetts. Poet who teaches at Wellesley College; winner of numerous awards; books include *Descending Figure* (1980) and *The Triumph of Achilles* (1985).

Linda Gregg (Born 1942). Born in New York State, lives in Chicago. Poet and teacher whose awards include a Guggenheim Fellowship; author of *The Sacraments of Desire* (1991) and other books.

Red Grooms (Born 1937). Born in Tennessee, lives in New York City. Artist whose fanciful, often humorous creations include films, happenings, assemblages, portraits, and life-sized "environments" made of various materials.

Chaim Gross (1904–1991). Born in Austria, moved to New York City in 1921. Sculptor whose work in wood, more recently in bronze, is found in many public buildings as well as in museums and private collections. Also an illustrator of stories for children.

O. Louis Guglielmi (1906–1956). Born in Egypt, brought to New York City in 1914. Artist who worked as a WPA muralist in the 1930s, compassionately portrayed the poor in his own paintings, but later adopted a much more abstract style.

Robert Gwathmey (1903–1988). Born in Virginia, later lived in New York. Painter whose strongly drawn pictures of African Americans in Southern settings began with prizewinning murals in the 1930s.

H.D. (Hilda Doolittle) (1886–1961). Born in Pennsylvania, lived mostly in Europe after 1911. "Imagist" poet who frequently wrote about emotional conflicts; books include *Selected Poems* (1957), *Helen in Egypt* (1961) and several works of fiction.

Donald Hall (Born 1928). Born in Connecticut, lives in New Hampshire. Author, critic, editor, and teacher of poetry; has written *Kicking the Leaves* (1978) and *The Happy Man* (1986) among many other books.

O. B. Hardison, Jr. (1928–1990). Born in Texas, lived mostly in North Carolina and in Washington, D.C. True man of letters, equally at home in poetry or prose, reading or writing, learning or teaching; provocative books include *Disappearing Through the Skylight: Culture and Technology in the Twentieth Century* (1989).

Childe Hassam (1859–1935). Born in Massachusetts, lived in the Boston area. Internationally recognized as a leading American Impressionist; some of his loveliest pictures were painted at the home of poet Celia Thaxter, on an island near the coast of New Hampshire.

Robert Hayden (1913–1980). Born in Michigan, later lived in Tennessee. Poet, university professor whose books including *Selected Poems* (1966) and *Angle of Ascent* (1975) have brought him belated recognition.

Anthony Hecht (Born 1923). Born in New York City, lives in Washington, D.C. Poet, critic, professor at Georgetown University; books include *The Hard Hours* (1967) and *The Transparent Man* (1990); among many other awards and honors, he received the Pulitzer Prize in 1968.

John Holmes (1904–1962). Born and lived mostly in Massachusetts. Talented poet and essayist, now generally neglected, who taught English at Tufts University for many years.

Washington Irving (1783–1859). Born in New York City, lived in New York and in Europe at various times. Businessman who became a writer of enormously popular tales, such as "Rip Van Winkle" and "Legend of Sleepy Hollow"; also served as U.S. minister to Spain, 1842–46.

Henry James (1843–1916). Born in New York City, traveled extensively, moved to England in 1876, naturalized in 1915. Very prolific, highly regarded writer whose intricate novels include *The Portrait of a Lady* (1881), *The Bostonians* (1886), *The Ambassadors* (1903), and other studies of high society.

Randall Jarrell (1914–1965). Born in Tennessee, lived in Texas, North Carolina, Indiana, Ohio, and other places. Poet, critic, professor, known for brilliance and sophistication; Consultant in Poetry at the Library of Congress, 1956–58; received the National Book Award in 1961.

Robinson Jeffers (1887–1962). Born in Pittsburgh, later moved to California. Poet who wrote in seclusion amid the natural beauty of the Pacific coast; books include *The Woman at Point Sur* (1927), *Give Your Heart to the Hawk and Other Poems* (1933).

Luis Jimenez (Born 1940). Born in Texas, lives in New Mexico. Sculptor, teacher whose large fiberglass figures capture the color and vigor of Hispanic-American women and men.

Eastman Johnson (1824–1906). Born in Maine, lived in New York City. A leading genre painter of evocative outdoor scenes, also known for family portraits and other groups that demonstrate his growth as an artist.

William H. Johnson (1901–1970). Born in South Carolina, lived in Europe 1926–38, later in New York City. Expressionist artist who developed a deceptively simple and self-consciously primitive style for his vivid paintings of African Americans in farm, prison, church, and other settings.

Jacob Kainen (Born 1909). Born in Connecticut, lives in Maryland. Printmaker who worked in woodcut, silk screen, and other media; his style gradually evolved from the social realism of the 1930s to more abstract portraits in the 1950s and later.

Morris Kantor (1896–1974). Born in Russia, brought to the United States in 1906, lived in New York City. Painter who explored Futurism, Cubism, and other styles as alternatives to the realism that characterizes his best-known work.

William Sergeant Kendall (1869–1938). Born in New York State, studied in Philadelphia and Paris, lived in New York, Connecticut, and Virginia. Painter who won several prizes for his work; also served as Dean of the School of Fine Arts, Yale University, 1913–22.

Rockwell Kent (1882–1971). Born in New York State, studied and lived in various parts of the United States and abroad. Painter, printmaker, writer who often depicted winter and arctic scenes based upon his travels in New England, Alaska, Newfoundland, and Greenland.

Rodger P. Kingston (Born 1941). Born in Seattle, lives in Massachusetts. Photographer who tries like Walker Evans to piece together a "transcendent documentary" of his vision of America.

John Koch (1909–1978). Born in Ohio, studied in Paris, lived in New York City, later in Michigan and France. Realist painter, teacher whose work appears in several museums.

Leon Kroll (1884–1974). Born, lived in New York City. Realist painter, teacher who described his artistic interests: "The living, breathing light over forms. I sense the beyondness and the wonder of simple living people and the things they do."

Yasuo Kuniyoshi (1893–1953). Born in Japan, brought to the United States in 1906, lived in California and New York. Versatile artist who painted "primitive" fantasy scenes in the 1920s, later explored more complicated techniques and subjects.

Gaston Lachaise (1882–1935). Born in Paris, came to the United States in 1906, lived in Boston, later in New York City. Sculptor best known for his large, stylized, voluptuous female nudes, especially the several versions of *Standing Woman* (1912–27, 1932).

John La Farge (1835–1910). Born and lived mostly in New York City, studied in Europe, traveled widely. Painter, author who was among the first to create murals and stained glass in this country, believing that public monuments should be works of art; also visited Japan and Tahiti in search of the exotic.

Ring Lardner (1885–1933). Born in Michigan, lived in Ohio and New York. Reporter, sportswriter, syndicated columnist, who is remembered for his down-to-earth fiction, including *You Know Me, Al* (1916) and *How to Write Short Stories (With Samples)* (1924).

Mary Ann Larkin (Born 1945). Born in Pittsburgh, lives in Washington, D.C. Writer, teacher, and poetry reader, whose books include *The Coil of the Skin* (1982).

Jacob Lawrence (Born 1917). Born in New Jersey, later moved to the state of Washington. Artist whose pictorially complex paintings explore various historical and contemporary themes relating to the lives of African Americans.

William Robinson Leigh (1866–1955). Born in West Virginia, studied in Munich, 1883–96, lived in New York City and elsewhere. Magazine illustrator and artist who enjoyed his greatest success with sketches and paintings of the American West. Later traveled to Africa and painted cycloramas for the American Museum of Natural History, New York.

Emanuel Gottlieb Leutze (1816–1868). Born in Germany, grew up in Philadelphia, studied and worked in Düsseldorf, 1840–59, before settling in the United States. Popular history painter of large, dramatic scenes such as *Washington Crossing the Delaware* (1851) and *Westward the Course of Empire Takes Its Way* (1861–62).

Sinclair Lewis (1885–1951). Born in Minnesota, later lived in Vermont and in Europe. Author of *Main Street* (1920), *Babbitt* (1922), and other novels that mocked and shocked the middle class; he refused the Pulitzer Prize for fiction in 1926, but accepted the Nobel Prize in 1930.

Henry Wadsworth Longfellow (1807–1882). Born in Maine, lived mostly in Massachusetts. Poet who taught at Harvard University, published many books of verse, and largely created an American mythology with his tales of Evangeline, Hiawatha, Paul Revere, the village blacksmith, and other figures.

Amy Lowell (1874–1925). Born and lived in Massachusetts, traveled much abroad. Poet who wrote numerous books, made many public appearances to increase the public's appreciation of poetry; awarded the Pulitzer Prize in 1926.

George Luks (1867–1933). Born in Pennsylvania, studied in Europe, lived in New York City. A member of "The Eight," whose lively, realistic paintings of everyday

scenes reflect his early training as a newspaper artist-reporter in Philadelphia.

Helen Lundeberg (Born 1908). Born in Chicago, moved to California in 1912. Surrealist and Post-Surrealist painter who called her earlier style "New Classicism"; she later explored other styles and techniques, including murals (for the WPA) and acrylics.

Thomas McGrath (1916–1989). Born and lived in Minnesota. Poet, novelist, teacher, who expressed some of the strongest feelings of his generation in such poems as "Ode for the American Dead in Asia" about the wars in Korea and Vietnam.

Frederick William MacMonnies (1863–1937). Born and lived in New York City, studied in Paris. Sculptor whose *Bacchante and Infant Faun* (1894), included here, was commissioned for the Boston Public Library but rejected by indignant citizens. Removed to The Museum of Modern Art, New York, it attracted much attention and made the reputation of the artist.

Paul Manship (1885–1966). Born in Minnesota, studied in Rome, lived in New York City and elsewhere. Popular artist, best known for ornamental, public sculpture such as *Prometheus* (1932–34) in Rockefeller Center, New York City; he learned about classical Greek and Roman statues but developed his own style.

Moissaye Marans (1902–1977). Born in Russia, moved to the United States, lived in New York City. He worked as a WPA artist and won several prizes for his paintings but did not become widely known.

Marisol (Escobar) (Born 1930). Born in Paris, studied there and in New York City, moved to California. Sculptor whose brightly colored assemblages and other works are found in major museums in the United States and abroad.

Reginald Marsh (1898–1954). Born in Paris, brought to the United States in 1900, lived mostly in New York City. Traditional artist who produced thousands of drawings for newspapers and magazines before turning to realistic painting and etching, in which his favorite subjects were people in crowded urban scenes.

Alfred Henry Maurer (1868–1932). Born in New York City, studied there and abroad. While living in France, 1897–1914, he abruptly switched from conventional painting to the modernist approach, ahead of his American contemporaries; later he experimented with Cubism and other styles, his work becoming increasingly abstract.

Gari Melchers (1860–1932). Born in Michigan, studied and worked in Europe, 1877–1914, later lived in Virginia. Innovative artist whose strong forms and colors distinguish his oil paintings as well as the murals he completed at the Library of Congress (1900) and elsewhere.

Edna St. Vincent Millay (1892–1950). Born in Maine, lived mostly in New York City and in Massachusetts. Poet and playwright, awarded the Pulitzer Prize in 1923, who did much for the cause of women's liberation.

Marianne Moore (1887–1972). Born in Missouri, lived in Pennsylvania and in New York City. Poet, literary critic, and translator; received numerous honors, both the Pulitzer Prize and the National Book Award in 1952 for *Collected Poems*, included in *Complete Poems* (1981).

Thomas Moran (1837–1926). Born in England, grew up in Philadelphia, traveled extensively in the West, finally settled in California. Painter best known for magnificent, idealized canvases such as *The Grand Canyon of the Yellowstone* (1872), now at NMAA.

Harry Siddons Mowbray (1858–1928). Born in Egypt, brought to the United States in 1859, lived here and abroad. Painter who executed various commissions for J. P. Morgan, F. W. Vanderbilt, and other wealthy clients; also directed the American Academy in Rome, 1902–4.

Elie Nadelman (1882–1946). Born in Poland, worked in Paris, came to New York City in 1914. Early modernist

sculptor who became widely known in Europe before moving to the United States. Here his work was influenced by folk art as well as classical forms, and he flourished for a time but fell into obscurity years before his death.

Ogden Nash (1902–1971). Born in New York State, lived in New York City. Writer and humorist who produced so many volumes of funny poems that he made it seem easy; books include *The Bad Parents' Garden of Verse* (1936) and *You Can't Get There from Here* (1957).

Howard Nemerov (1920–1990). Born in New York City, later moved to Missouri. Poet, professor at Washington University, St. Louis; Consultant in Poetry at the Library of Congress, 1963–64, and Poet Laureate, 1987–88; books include *The Painter Dreaming in the Scholar's House* (1968).

Louise Nevelson (1899–1988). Born in Russia, brought to Maine in 1905, lived in New York City starting in 1920. Internationally famous artist who created striking assemblages of found wooden forms, and sculptures in steel, aluminum, Plexiglas, and other materials. Her etchings are not as widely known.

Hugh Nissenson (Born 1933). Born and lives mostly in New York City. Writer, lecturer whose novel *The Tree of Life* (1985) has been highly praised, translated into six other languages.

Georgia O'Keeffe (1887–1986). Born in Wisconsin, later lived in Virginia and New York before going West. Dynamic artist whose most famous paintings are based upon the objects and landscapes she discovered in the New Mexico desert, starting in 1929.

Dorothy Parker (1893–1967). Born in New Jersey, lived in New York, Pennsylvania, California, and elsewhere. Writer of poetry, fiction, screenplays, reviews; known for sharp, sometimes hurtful wit; her short story "Big Blonde" won the O. Henry Prize in 1929.

Philip Pavia (Born 1912). Born in Connecticut, studied in Europe, settled in New York. Sculptor who went back to carving stone, after experimenting with bronze, because of his interest in "bouncing light."

Sylvia Plath (1932–1963). Born and lived in Massachusetts, later in England. Poet and novelist, posthumously awarded the Pulitzer Prize in 1981, whose suicide cut short a tragic life and a profound talent.

Edgar Allan Poe (1809–1849). Born in Boston, lived in Virginia, Pennsylvania, and New York City. Writer who produced a wealth of memorable poetry during his brief career, including *The Raven and Other Poems* (1845), as well as "The Murders in the Rue Morgue" (1841) and other mystery stories.

Ezra Pound (1885–1972). Born in Idaho, lived mostly in Europe. Poet, critic, editor, and translator who played an important part in the shaping of American poetry, despite his personal problems; of particular interest are *Personae* (1909), *The Pisan Cantos* (1948), and *Selected Poems* (1975).

Hiram Powers (1805–1873). Born and grew up in Vermont, later lived in Ohio before moving to Florence, Italy, in 1837. Sculptor who produced lifelike portrait busts such as *Andrew Jackson* (1835) and idealized figures such as *The Greek Slave* (1843) that helped to overcome the public's dislike of female nudity in art.

Maurice Prendergast (1859–1924). Born in Newfoundland, studied and lived in Boston and Paris, also visited Venice. Post-Impressionist painter whose oils and watercolors are charming scenes of people enjoying the park, the seashore, and other pleasant places.

John Crowe Ransom (1888–1974). Born and lived in Tennessee, later in Ohio. Poet, critic, professor, a strong influence on younger writers; received the National Book Award in 1964, among other honors.

Abraham Rattner (1895–1978). Born in New York State, lived in New York City and Paris. Expressionist artist who used vivid colors to simulate (and occasionally to design) stained-glass windows; he was especially effective in depicting the vulnerability of people.

Robert Rauschenberg (Born 1925). Born in Texas, lives and works in New York City and elsewhere. Extremely influential artist whose complex assemblages and other multimedia works reflect his intention to "act in the gap between life and art." He has also produced a number of striking lithographs.

Man Ray (né Emmanuel Radnitsky) (1890–1976). Born in Philadelphia, lived intermittently in the United States, but preferred Paris. Innovative painter, photographer, filmmaker who has been described as a Dadaist-Surrealist. Actress Ruth Ford (seen here in his photograph) also figures in both a film script and a photograph entitled *Ruth, Roses, and Revolvers* (1945).

Richard Realf (1834–1878). Born in England, came to the United States about 1854, lived in various places. Wandering poet who took his own life after many adventures and misadventures; his *Poems* (1898) was published posthumously.

Robert Reid (1863–1929). Born in Massachusetts, studied in France, lived and taught in New York City. Known primarily for his murals in the Library of Congress and other public buildings, he also painted bold, richly colored figures and landscapes in the Impressionist manner.

Alberto Ríos (Born 1953). Born and lives in Arizona. Writer, professor whose poetry books include *Whispering to Fool the Wind* (1982) and *Lime Orchard Woman* (1988).

Edwin Arlington Robinson (1869–1935). Born in Maine, later lived in New York City and elsewhere. Dramatic poet who caught the interest of Teddy Roosevelt and others with books such as *The Town Down the River* (1910) and *The Man Against the Sky* (1916); won the Pulitzer Prize in 1922, 1925, and 1928.

Theodore Robinson (1852–1896). Born in Vermont, studied and worked for many years abroad. Painter who lived in Giverny, 1887–92, was greatly influenced by Monet, and is generally considered to be the leading American Impressionist.

Hugo Robus (1885–1964). Born in Ohio, later studied in New York City and Paris. Primarily a Cubist painter until 1920, he became a sculptor whose lyrical, expressive style reflected his interest in "pure form," especially in the human body.

John Rogers (1829–1904). Born in Massachusetts, later lived in Chicago and New York City. Sculptor whose mass-produced plaster "Rogers Groups" of adults and children found places in many American homes and in some museums.

Cheryl Romney-Brown (Born 1938). Born in Utah, lives in Washington, D.C. Writer, teacher whose books include a volume of poetry, *Circling Home* (1990).

Mark Rothko (1903–1970). Born in Russia, came to Portland, Oregon in 1913, moved to New York City about 1925. Painter whose early work depicted urban scenes with isolated figures; later he developed the distinctive format of shifting rectangles in subtle colors that made him a leader of the Abstract Expressionist movement.

Muriel Rukeyser (1913–1980). Born and lived mostly in New York City. Woman of letters, teacher, social activist; received many awards for her poetry and translations. She hoped her *Collected Poems* (1978) would "reach that place where things are shared and we all recognize the secrets," but she is not widely appreciated today.

Albert Pinkham Ryder (1847–1917). Born in Massachusetts, moved to New York City in 1870. Known for his restless seascapes and other haunting pictures of nature transformed, he also produced a number of much gentler paintings on decorative leather screens.

Augustus Saint-Gaudens (1848–1907). Born in Ireland, brought to the United States, lived in New York City and New Hampshire but spent many years in Rome and Paris. His brilliant sculptures include relief plaques, private commissions, and large public monuments such as *The Robert Gould Shaw Memorial* (1884–97) in Boston.

John Singer Sargent (1856–1925). Born in Florence, traveled frequently in Europe and the United States. Prominent artist who painted naturalistic watercolors and perceptive society portraits in addition to larger masterpieces such as *El Jaleo* (1882).

Delmore Schwartz (1913–1966). Born and lived mostly in New York City. Poet, teacher whose life and work deteriorated after a brilliant start with his first book, *In Dreams Begin Responsibilities* (1939).

George Segal (Born 1924). Born in New York City, lives in New Jersey. Initially a painter, later a sculptor, best known for life-size figures made from white, plaster-impregnated bandages but often placed in realistic positions and settings.

Anne Sexton (1928–1974). Born in Massachusetts, lived there and elsewhere. Emotionally powerful writer whose posthumously published *Complete Poems* (1981) includes hard-to-find volumes such as *Live or Die* (1966) and *Love Poems* (1969).

Karl Shapiro (Born 1913). Born in Baltimore, lives in California. Poet, professor emeritus at the University of California, Davis; Consultant in Poetry at the Library of Congress, 1946–47; winner of the Pulitzer Prize, 1945, and other awards.

Joseph Henry Sharp (1859–1953). Born in Ohio, studied in Europe, lived in California and New Mexico. The father of the artists' colony at Taos, starting in 1912, he specialized in portraits of Indians and larger paintings of Indian life, some of which are now at the NMAA.

Millard Sheets (Born 1907). Born and lives in California. Painter, etcher, illustrator, designer, who has received numerous prizes for his work.

Rhoda Sherbell (Born 1933). Born in New York City, lives in New York State. Contemporary sculptor, consultant, teacher who has won many awards. The cast for the sculpture shown here, *William and Marguerite Zorach* (1964), was commissioned by the Smithsonian.

John Sloan (1871–1951). Born in Pennsylvania, lived in Philadelphia and New York City. Originally a newspaper illustrator, he became a leading artist, one of "The Eight," realistically depicting city dwellers in lively paintings and in his intimate "New York City Life" series of etchings (1904).

Raphael Soyer (Born 1899). Born in Russia, came to New York City in 1912. Painter, teacher whose artistic style shifted from a primitive manner (1920s) and Depression subjects (1930s) to sketchlike studies and fully realized paintings of women.

Lilly Martin Spencer (1822–1902). Born in England, brought to Ohio in 1833, later moved to New York City. Her charming, sometimes sentimental paintings of domestic scenes were expertly done and quite popular among her contemporaries, but her reputation faded like the rose.

Theodore Spencer (1902–1949). Born in Pennsylvania, lived mostly in Massachusetts. Harvard professor, Shakespearean scholar, who also wrote *Poems 1940–47* (1948).

Gertrude Stein (1874–1946). Born in Pennsylvania, lived mostly in Paris after 1903. Writer, influential stylist and critic, art collector who sat for portraits by Picasso, 1906, and other friends; her studies of women in *Three Lives* (1909) made her famous.

Joseph Stella (1877–1946). Born in Italy, brought to New York City in 1896, visited Europe in later years. Artist who experimented with a variety of approaches (ranging from Futurism to classic idealism) and techniques (including oils, pastels, and collage).

Wallace Stevens (1879–1955). Born in Pennsylvania, later lived in Connecticut. Intellectual who found the time to write poetry in his successful career as insurance executive; received the National Book Award in 1951 and 1955, the Pulitzer Prize in 1955, other honors.

Gilbert Stuart (1755–1828). Born in Rhode Island, trained in London, worked in the U.S. and the British Isles. An ingenious, insightful, but unusually money-minded artist whose portraits of George Washington (especially the image appearing on the $1 bill) have become part of the American heritage.

Charles Sullivan (Born 1933). Born in Boston, lives in Virginia. Poet, author, and editor of art-related books for adults and children; dean at Georgetown University.

Celia Thaxter (1835–1894). Born and lived in New Hampshire. Enterprising writer who published several books combining her poetry and prose with pictures by Childe Hassam and other artists; now getting more attention after a century of neglect.

Abbott Handerson Thayer (1849–1921). Born in Boston, lived in New York and New Hampshire among other places. Known for his early angelic paintings of young women, he later produced a series of remarkable landscapes. His publication on "protective coloration in nature" helped American technicians to develop camouflage in World War I.

Henry David Thoreau (1817–1862). Born and lived in Massachusetts. Nonconformist who "went to the woods," enjoyed solitude, wrote *Walden* (1854), had little immediate impact on others, but is now regarded as one of the most important American writers of the 19th century.

George Tooker (Born 1920). Born in New York City, lives in Vermont. Artist whose recent work in embossed paper is a considerable departure from his earlier, more depersonalized paintings such as *Subway* (1950) and *The Waiting Room* (1959), the latter now at NMAA.

Abraham Walkowitz (1880–1965). Born in Russia, brought to New York City in 1889. Artist who made hundreds of drawings of the dancer Isadora Duncan, starting in 1907; later he experimented with other styles, media, and subjects.

Andy Warhol (1928–1987). Born in Pennsylvania, lived mostly in New York City. Painter, graphic designer, and filmmaker who became a leading Pop artist. Of his often-reproduced celebrity portraits he said: "I think it would be terrific if everyone looked alike."

Laura Wheeler Waring (1887–1948). Born in Connecticut, studied in Philadelphia and Paris, lived mostly in Pennsylvania. Artist, teacher whose paintings of distinguished African Americans are found in NMAA, the National Portrait Gallery, and the National Archives.

Max Weber (1881–1961). Born in Russia, brought to New York City in 1891, later traveled in Europe. The first modern artist to have a show in an American museum (Trenton, N.J., 1913), he tried many styles and media, including woodcuts and sculpture, before finding a more personal approach in the 1920s.

Benjamin West (1738–1820). Born in Pennsylvania, studied art abroad, worked mostly in England. His well-executed paintings of mythological and historical subjects are found in major collections; his portraits include *Mary Hopkinson* (c. 1764) and a final *Self-Portrait* (1819), both at NMAA.

Walt Whitman (1819–1892). Born in New York State, lived in New York City, New Jersey, and elsewhere. Writer whose *Leaves of Grass*, published in 1855 and often revised thereafter, set new standards for the subjects and techniques of American poetry.

John Greenleaf Whittier (1807–1892). Born and lived in Massachusetts. Popular poet who wrote innumerable books of nostalgic verse about subjects great and small; also devoted himself to the cause of abolishing slavery.

Richard Wilbur (Born 1921). Born in New York City, lives in Massachusetts. Poet, professor, man of letters, writer-in-residence at Smith College; recipient of many honors, including the Pulitzer Prize and the National Book Award, 1957; Poet Laureate and Consultant in Poetry at the Library of Congress, 1987–88.

John Wilde (Born 1919). Born and lives in Wisconsin. Artist whose unusual paintings and drawings have won many awards; professor of art, 1969–82, at the University of Wisconsin.

Thomas Wolfe (1900–1938). Born in North Carolina, lived in New York City and elsewhere. Writer, teacher, who produced several highly acclaimed novels, including *Look Homeward, Angel* (1929) and *You Can't Go Home Again* (1940); died of pneumonia during a trip to Europe.

Elinor Wylie (1885–1928). Born in New Jersey, lived in England, New York City, and elsewhere. Writer whose social prominence and glamour led some critics to overlook the sharp images and subtle ideas in her poetry and prose.

William Zorach (1887–1966). Born in Lithuania, brought to Ohio in 1891, moved to New York City in 1912. Artist who ceased oil painting in 1922, having discovered that sculpture suited him better; he tried to let the stone or wood take its own shape, whether in large public monuments or in smaller works.

Grateful acknowledgment is made for permission to reproduce the work of the following writers. All possible care has been taken to trace ownership of every selection included and to make full acknowledgment. If any errors or omissions have occurred, they will be corrected in subsequent editions, provided that notification is sent to the publisher.

Conrad Aiken, "Music I Heard," from *Collected Poems*, 2nd edition, by Conrad Aiken. Copyright © 1953, 1970 by Conrad Aiken. Reprinted by permission of Oxford University Press, Inc.

Sherwood Anderson, excerpt from short story "The Return," by Sherwood Anderson, in *Death in the Woods and Other Stories*, Norton. Copyright 1925 by Century Co. Copyright renewed 1952 by Eleanor Copenhaver Anderson. Reprinted by permission of Harold Ober Associates Incorporated.

James Baldwin, excerpt from *If Beale Street Could Talk* by James Baldwin. Copyright © 1974 by James Baldwin. Used by permission of Doubleday, a division of Bantam Doubleday Dell Publishing Group, Inc.

Thomas Beer, excerpt from essay "The Titaness," published in *Hanna, Crane and the Mauve Decade*. Copyright 1941, renewed 1969 by Alfred A. Knopf, Inc. Reprinted by permission of the publisher.

Robert Bly, "The Indigo Bunting" and "A Man and a Woman Sit Near Each Other," from *Loving a Woman in Two Worlds* by Robert Bly. Copyright © 1985 by Robert Bly. Used by permission of Doubleday, a division of Bantam Doubleday Dell Publishing Group, Inc.

Arna Bontemps, "A Black Man Talks of Reaping," from *Personals* by Arna Bontemps. Reprinted by permission of Harold Ober Associates Incorporated. Copyright © by Arna Bontemps.

Gwendolyn Brooks, "Jessie Mitchell's Mother" and "Old Mary" from *Blacks* by Gwendolyn Brooks. © Gwendolyn Brooks, 1991. Third World Press, Chicago.

Lucille Clifton, "if i stand in my window," copyright © 1987 by Lucille Clifton. Reprinted from *good woman: poems and a memoir, 1969–1980* by Lucille Clifton with permission of BOA Editions, Ltd., 92 Park Avenue, Brockport, N.Y., 14420.

e. e. cummings, "my love" is reprinted from *Tulips & Chimneys* by e. e. cummings, edited by George James Firmage, by permission of Liveright Publishing Corporation. Copyright 1923, 1925 and renewed 1951, 1953 by e. e. cummings. Copyright © 1973, 1976 by the Trustees for the e. e. cummings Trust. Copyright © 1973, 1976 by George James Firmage.

James Dickey, "The Scarred Girl" from *Poems 1957–1967*, copyright 1963 by James Dickey. Wesleyan University Press by permission of University Press of New England.

Hilda Doolittle, *see* H.D.

Theodore Dreiser, excerpt from essay "My Brother Paul," from *Twelve Men*. Copyright 1919 Boni & Liveright. Copyright renewed 1946 by Helen Richardson Dreiser. Published with permission of The Dreiser Trust.

Max Eastman, "Animal," from *Poems of Five Decades*, copyright 1954 by Max Eastman, copyright renewed by Yvette Szekely Eastman 1982. All rights reserved.

F. Scott Fitzgerald, excerpt from *The Great Gatsby*. Reprinted with permission of Charles Scribner's Sons, an imprint of Macmillan Publishing Company, from *The Great Gatsby* by F. Scott Fitzgerald. Copyright © 1991 by Eleanor Lanahan, Matthew J. Bruccoli, and Samuel J. Lanahan as Trustees under Agreement dated July 3, 1975, created by Frances Scott Fitzgerald Smith. Copyright

INDEX